In the Footsteps of
Van Gogh

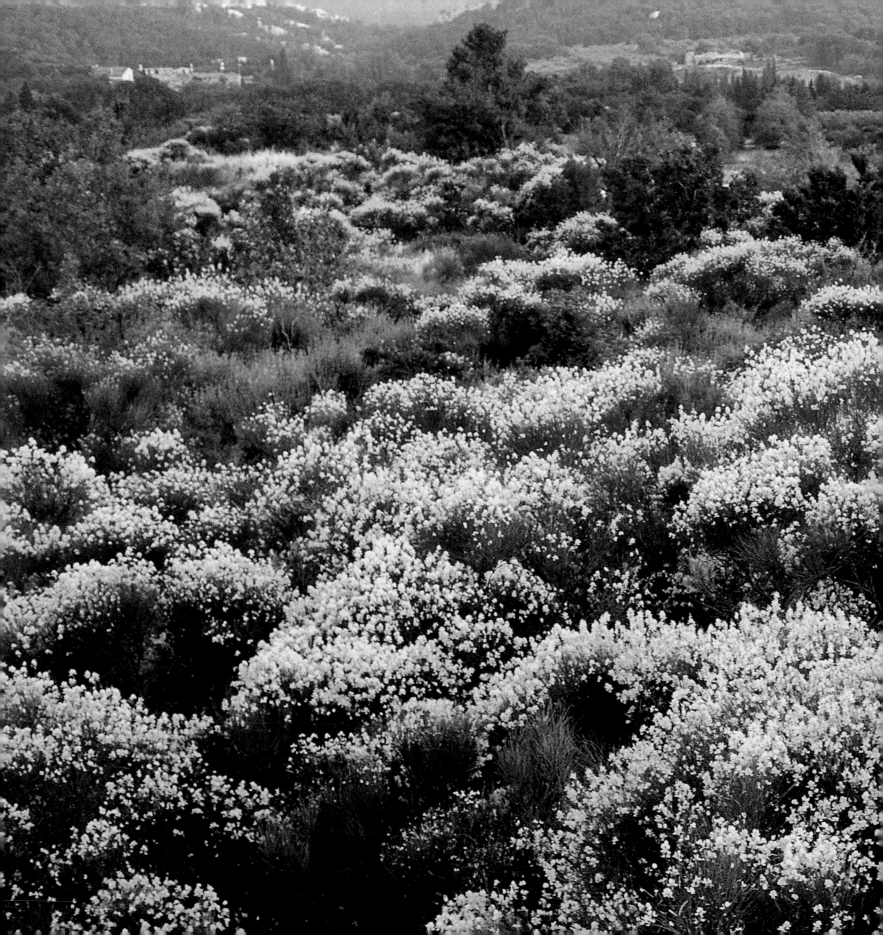

TEXT
Gilles Plazy

PHOTOGRAPHS
Jean-Marie del Moral

In the Footsteps of

Van Gogh

PENGUIN STUDIO BOOKS

Contents

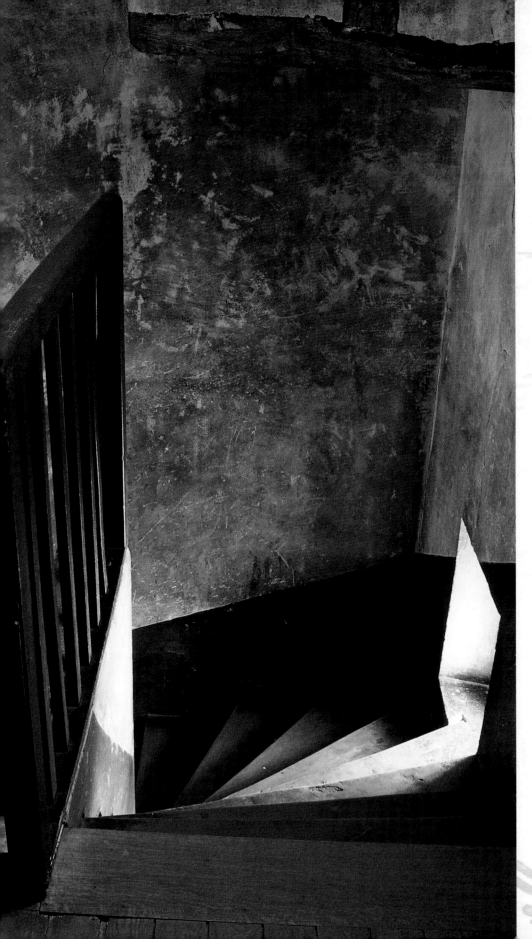

The staircase at the Ravoux
Inn.
*Auvers is very beautiful, among
other things a lot of old
thatched roofs, which are
getting rare. So I should hope
that by settling down to do some
canvases of this there would be a
chance of recovering the
expenses of my stay—for really
it is profoundly beautiful, it is
the real country, characteristic
and picturesque.*
To Theo and Jo, May 21,
1890.

A Vision Accomplished— Auvers-sur-Oise

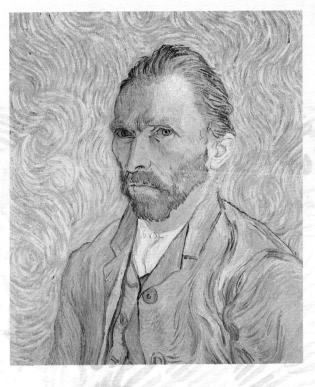

Self-Portrait, Saint-Rémy, September 1889. Musée d'Orsay, Paris. *For myself, I can see from afar the possibility of a new art of painting, but it was too much for me, and it is with pleasure that I return to the north.* To Isaäcson, May 1890.

This is where an artist died. He was no ordinary artist—he was Vincent Van Gogh, the most famous and best-loved of all painters. A legendary hero. The archetypal artist, with his soul in torment, totally misunderstood and unloved, but with so much love to give. Here, in Auvers-sur-Oise, Vincent Van Gogh died, and it was no ordinary death; a gunshot wound in a field of wheat, followed a few hours later by a blessed release. Suicide. Vincent Van Gogh died in his room at the Auberge Ravoux, on July 29, 1890, and it is here that the legend is rooted. People come from all over the world to see the room where he lay dying, to see the cemetery where he is buried next to his brother Theo. To see the wheatfields, the church, the town hall, Daubigny's garden, Dr. Gachet's house, so many motifs glorified by the genius that elevated them to icons of modern art. They come to eat lunch at the inn where he took his meals and where his memory has been reverently preserved.

Shortly afterward, the little railway station was the subject of a painting by Vlaminck, and a commemorative plaque was erected on one of the walls. For painters did not cease to come to Auvers after Vincent's death. For, like Barbizon or Pont-Aven, Auvers has never ceased to be a place of pilgrimage for painters. It has a significant place in the history of art. When Vincent arrived here, on May 21, 1890, just over two months before he was to die, this village near Paris already boasted artist residents. Charles François Daubigny had settled here. A friend of Corot's, Daubigny was one of those amiable landscape painters who keep an equal distance from the flights of fantasy of Romanticism and the gravitas of academia. Valmondois, a small

neighboring town, held fond memories for him, for he had spent part of his childhood there. He rented a house, fitted out a rowboat in order to paint at his leisure on the river Oise, and had a studio built, which can be visited today. It still holds pieces of his furniture, a few paint-ings, and the great pastoral frescoes of the master of the house and his friend Corot.

Vincent respected Daubigny, a solid, unpreten-tious painter, who bore witness to a true love of nature. It was Daubigny whose garden he painted. It was situated in front of the station beside the café, which is still open for travelers today. *Daubigny's Garden* is not strictly speaking a true title, because it is in fact the garden of the house where his widow was living when Vincent first came to Auvers. There is a small signpost with a reproduction of the painting, informing the visitor that Vincent placed his easel on this very spot.

This spot is now in the main street of a village where cars, buses, and coaches ferry tourists around the various places Vincent painted. The place where the tragedy unfolded is situated a few kilometers from Pontoise and Cergy-Pontoise in the middle of the modern world. Thus the almost forgotten Daubigny, known only to a few experts, admired by a handful of art enthusiasts, benefits from the crowds who flock to see the younger painter, who was sorry he arrived too late to meet him (Daubigny died in Paris in 1878).

Cézanne also came to Auvers, as did Pissarro

and Guillaumin. After the Seine, the Impressionists discovered the river Oise. They loved to paint in the open air, particularly on the banks of rivers. They also found that life was less expensive in the countryside than in Paris. It was Pissarro, the likable instigator of Impressionism, who strove harder than anyone to put more light into painting, who had attracted Cézanne to Pontoise. Cézanne had not yet become the great recluse of Aix-en-Provence, and he was looking for a place where he could work and support a wife and child. Cézanne had met a strange doctor in Auvers, an art enthu-

siast and an engraver, who persuaded him to try the technique of aquafortis. Cézanne painted a few scenes of Auvers, *The Suicide's House*, and *Dr. Gachet's House*. In doing so, he completely revised his palette, found a new kind of light and was thereby initiated into Impressionism. He was only at the beginning of his path then, far from the mountain of Sainte-Victoire, far from that solid, timeless painting that was the opposite of the ephemeral cultivated by the friends of his youth. Then he suddenly took off again to find new inspiration, once more in search of that painting that he

The church and the countryside at Auvers-sur-Oise.

OPPOSITE
The Ravoux Inn and Vincent's room.

And as for myself at the moment I am still afraid of the noise and the bustle of Paris, and I immediatley went off to the country—to an old village.
To his sister, June 1890.

tion for the most southern of all painters, the wildest of the artists from Marseilles, Adolphe Monticelli. Van Gogh had come away from the North—Holland, Belgium, and the Flemish chiaroscuro. He had come to Paris to study Delacroix, Millet, and Impressionism. He had gone down to Arles to confront the sun and he had come back from there, perhaps a little too soon for his liking, because he felt as if he had not learned everything that was to be learned there. But he felt no great frustration about moving northward. He was happy to be moving closer to Paris and to his brother Theo, the art dealer, his patron and *alter ego*, who was later to be buried beside him in the cemetery at Auvers. The Paris area was neither the North nor the South. Here, life was happy, balanced, generous, with no romantic disharmony. It was certainly not a place of tragedy. It was the countryside of Millet, one of his mentors, one of the painters who knew how to paint country people.

The leading influence on Vincent in Auvers was above all Dr. Gachet. He was an eccentric, an expert in homeopathic medicine, who practiced in Paris three days a week, but who had been living in Auvers since 1872. He had always been passionately fond of art, had himself painted from an early age, and after a stay in Belgium, even adopted the Flemish pseudonym of Van Ryssel to sign his paintings. He had obtained his title of Doctor at Montpellier after presenting a thesis entitled *Study of Melancholia* in 1890. It was there that he had met Courbet. Gachet was sixty-two and a widower with a daughter of twenty-one, called Marguerite. There are two portraits of Marguerite by Vincent. The doctor was acquainted with most of the Impressionists

could sense but was just outside his reach. The painting that he was to search for desperately for more than twenty years.

Cézanne was another feather in the cap for Auvers in the eyes of Van Gogh. They were not close to one another, but Cézanne represented the South of France, the Provence to which Vincent had been lured by the sunshine. The place he later returned from, in poor health, but full of expectations because of his new-found confidence and self-reliance. He was determined to make the link between the schools of the North and the South. Cézanne and Van Gogh shared the same admira-

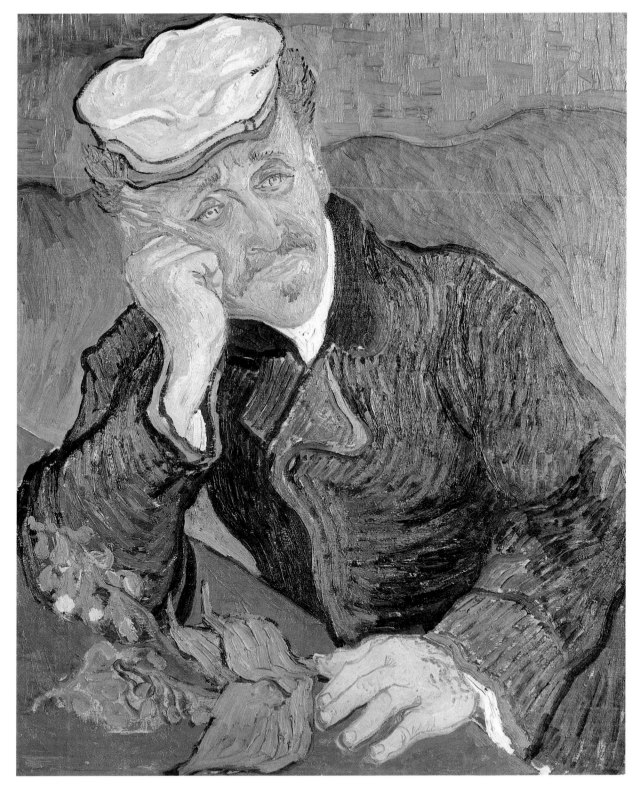

Portrait of Dr. Gachet with a Sprig of Digitalis. Auvers-sur-Oise, June 1890.
Musée d'Orsay, Paris.
I have seen Dr. Gachet, who gives me the impression of being rather eccentric, but his experience as a doctor must keep him balanced enough to combat the nervous trouble from which he certainly seems to me to be suffering at least as seriously as I.
To Theo and Jo, May 21, 1890.

OVERLEAF
Wheatfield at
Auvers-sur-Oise.

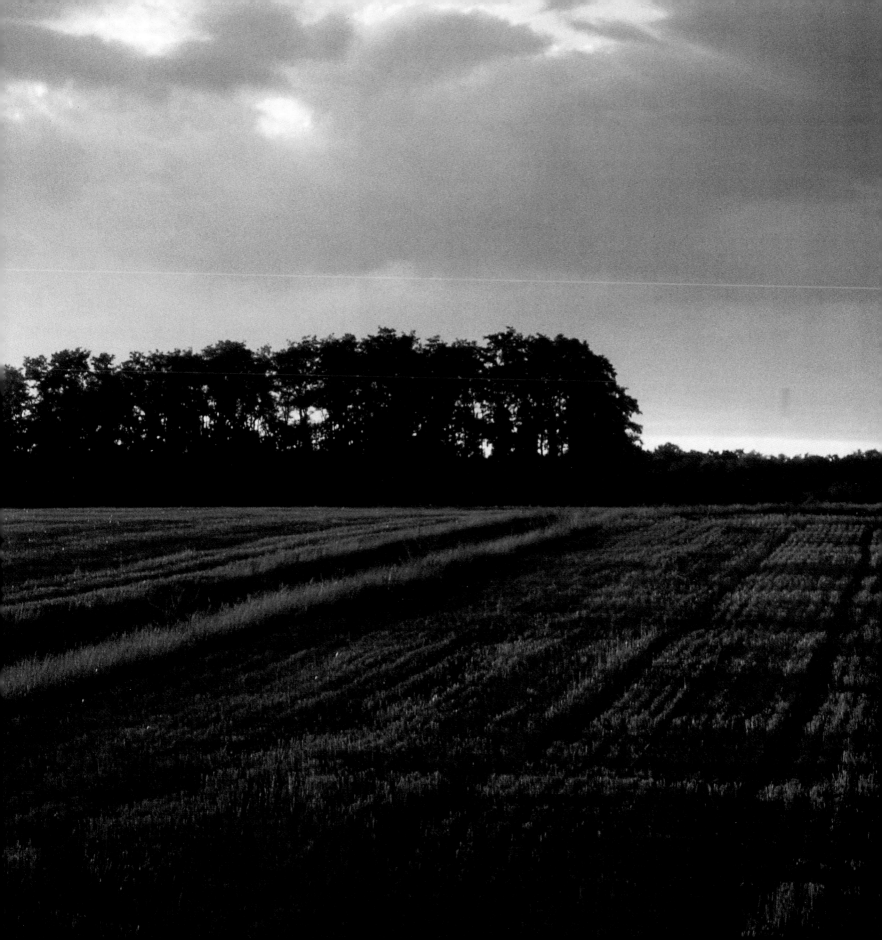

(Manet, Renoir, Monet, Sisley) and was an active member of the Indépendants who, since 1884, brought together a new generation of avant-garde artists including Seurat and Signac. This doctor-artist seemed to Theo Van Gogh to be the ideal man to look after his brother. Vincent had almost lost his sanity at the Saint-Rémy asylum, but he was not mad. Ill, certainly, subject to attacks that were no doubt closer to epilepsy than to dementia, but during which he totally lost control of himself.

So for the moment he couldn't live normally, independently, anymore. He couldn't paint; it exhausted him, left him feeling stunned. Here, closer to Paris, he would be less isolated, with friends around him for exchanging ideas, sharing projects, in the mild climate where he would feel closer to his homeland in the North. Perhaps he would regain his mental balance now that he had a better idea of what he wanted to paint, what he was going to paint. Pissarro had mentioned Gachet to Theo, who was looking for a way to take Vincent out of the asylum. Auvers, in the company of Dr. Gachet, the memory of Daubigny, pretty subjects to paint, within easy reach of Paris and Theo, his young wife, and their baby who was his namesake; Auvers would be the place where Vincent would be in his element and would finally gain recognition as the major artist that he really was. This would allow him to live off the fruit of his labors, no longer having to rely on his brother to support him. Vincent felt so completely dependent on Theo—not just on his generosity, but on his praise and his confidence in him. Vincent used to say that the paintings were a joint effort, since Theo had provided the canvases on which the works were produced, and even if they did not sell immediately, Vincent knew that they were worth

much more than just the material outlay.

The house of Dr. Gachet is situated a little away from the village center in a street that now bears his name. The house itself is not open to visitors, but it can be viewed from the outside. Vincent was a regular visitor and even painted there.

He painted a portrait of the doctor and of his daughter. He also did still lifes, flowers, and views of the garden. He was invited to dine there and found the meals interminable, accustomed as he was to much more meager fare. He had survived for a such long time on only bread and coffee. He should initially have gone to see the doctor in his surgery in Paris, but he was too impatient to get out of the city and settle somewhere to paint. When he did meet the doctor, he immediately liked him. He could sense similarities between them, but he soon became irritated by him. There was a strangeness about him. In fact he appeared to be even more insane than Vincent was and he was the one who had actually spent time in an asylum! Gachet was sixty-two, Vincent thirty-seven. The age difference was not very important, just significant enough for the doctor to feel comfortable in the role of protector.

He had an inn in mind where the painter could stay, the Auberge Saint-Aubin, but at six francs per day it was rather expensive for Vincent, who had to be very careful with what little money he had to live on, so he set out to look for a place for himself. He settled on an arrangement with a couple named Ravoux, who ran a café opposite the town hall and who had a few rooms to let. Three francs fifty centimes was a much more reasonable sum and included a small room on the ground floor where he could work and where he could leave his canvases to dry. Adeline, their daughter, posed for

Vincent several times. She was a beautiful girl, and she remembered him well as not being a very open sort of person by nature, not very talkative, but he always had a slight smile on his lips, and was sometimes carried away in a frank, jovial laugh that made him another person altogether. She was used to the eccentricities of artists, for there were always one or two at the inn. Auvers had had its share of painters, well-off ones like Daubigny, or poor ones like Vincent, and bohemians did not frighten anyone in Auvers. It wasn't like Arles,

OPPOSITE
Old house at
Auvers-sur-Oise.

The Town Hall
at Auvers-sur-Oise.
Unfortunately, it is expensive here in the village, but Gachet, the physician, tells me that it is the same in all the villages in the vicinity, and that he himself suffers much from it compared with before.
To his mother, June 1890.

Thatched Cottages in Cordeville,
June 1890.
Musée d'Orsay, Paris.
But I find the modern villas and
the middle-class country houses
almost as pretty as the old
thatched cottages that are
falling into ruin.
To Theo and Jo, May 1890.

OPPOSITE
A street in Auvers-sur-Oise.

where Vincent had experienced some hostility. In this spring of 1890, artists were coming and going in Auvers, but they did not gel to form a definite group like that at Pont Aven, a place where the Americans had congregated even before Gauguin arrived there. Tom Hisschig, another Dutch artist, stayed at the Ravoux inn in the month of June. He occupied the room next door to Vincent, and they fell into the habit of taking their meals together in the company of a third contemporary, Martiney de Valdiviase, from Cuba, who had a room in another inn.

No sooner had Vincent set down his belongings than he was running around the village looking for things to paint. A small lane, a few cottages, ivy and flowers on a wall, a wisteria trailing down behind a high gate, a staircase, the town hall with its red, white, and blue flags, the imposing church on the hill, and the still green wheatfields that would soon ripen and take on that golden color he had already painted in Provence the year before. He would have liked to have carried on painting cypresses and olive

trees, but he had had to leave the South of France slightly earlier than planned. There would certainly be other things here that he could paint; the countryside would offer him other subjects. The truth of the matter was that he did not need much to inspire him, just a feeling, an outline sketch, a few colors, and the intuition that he could possibly turn it all into a painting. The important thing was to paint, to paint as fast and as often as possible, and to paint better and better. Vincent must have known that he would not live to a very old age. He knew that he was worn out by the trials of a hard life, by poor nourishment, and by living under the threat of an illness that could recur at any time. He was in a hurry. He had always been in a hurry, first of all because he did not begin to paint until relatively late in life, at the age of thirty. He only saw himself as a painter after his failed attempt to become a preacher or even a lay preacher. Secondly, because this new adventure had to be experienced in all its intensity, not by painting "uncontroversial" paintings, like so many other artists, but by making the most of this adventure of modern painting to which the Impressionists had only half-opened the door, by taking example from the great masters, Delacroix and Millet, who had expressed life so well, revitalizing Western art with the brilliance of Japanese engravings, and even further, by glorifying color and causing it to resonate. To find the "high yellow note" was already a formidable challenge. He was very proud and ambitious, but he also had a definite humility. He wanted to be, and indeed he was, a pioneer exploring the way for others to advance even further. He was well aware that in Arles and Saint Rémy he had become another man, another painter, a maestro of the canvas with a style that was unique. But he was not to know that he had

very little time in front of him, hardly more than two months, seventy days in fact, a swan song. As soon as he arrived in Auvers he wrote to the art critic Isaäcson, who was in the process of publishing a series of articles on the Impressionists: "For myself I can see from afar the possibility of a new art of painting." Thinking that the art critic could soon have reason to mention his work, he wanted to express to him as clearly as possible what it was about, playing down his merits by declaring that he would never achieve anything significant (true or false modesty?), but giving a definition of a program for a new style of painting to come, a wave he intended to be a part of, and to show him clearly how this painting style would differ from Impressionism.

In this letter, Van Gogh managed to express how the opposition between the North and the South was crucial to his painting: the contrast between the North, where his roots were, that he left in favor of the South, and to which he had almost returned—the North of Europe with its willows and the Flemish masters—and the South, where he had just spent two years of his life, earnestly painting cypress and olive trees. He believed that the South, land of the olive groves, had not yet found its place in painting ("everything we have done with the olive tree amounts to rather little"). However, all his strenuous efforts, that disturbed his "Northern mind," only allowed him to "name these two things—cypress and olive tree—when in fact it is their symbolic language that should be expressed." A painter like Puvis de Chavannes, who is today regarded as slightly precious with his pale, highly stylized painting, would perhaps be capable of expressing olive trees to us. But how could it be done by a student of the old Northern School? For the question that confronted Vincent Van Gogh in the South was not only that of the olive tree itself but of the people who now live and work in olive, orange, and lemon groves. What Van Gogh sought in his painting, what he wanted to show in it, was man, that human being he never ceased to turn toward, which he always wanted to love. Vincent, whether he was apprentice preacher or painter, was a lonely man, constantly seeking to belong to a group of fellow artists.

On the first day he arrived, he wrote to his brother Theo and "Dear Jo," the sister-in-law that he had just met when passing through Paris: "Auvers is very beautiful, among other things a lot of old thatched roofs, which are getting rare." He told them about his first meeting with Dr. Gachet, how he also seemed to be suffering from some sort of "nervous complaint," and he intimated to them

The church at
Auvers-sur-Oise.

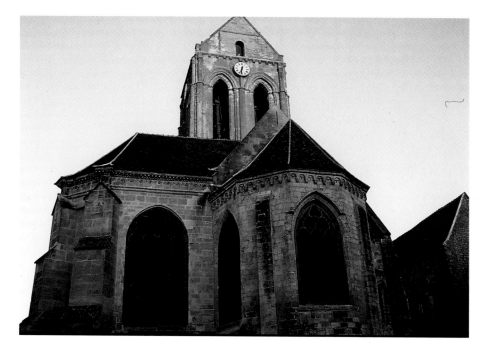

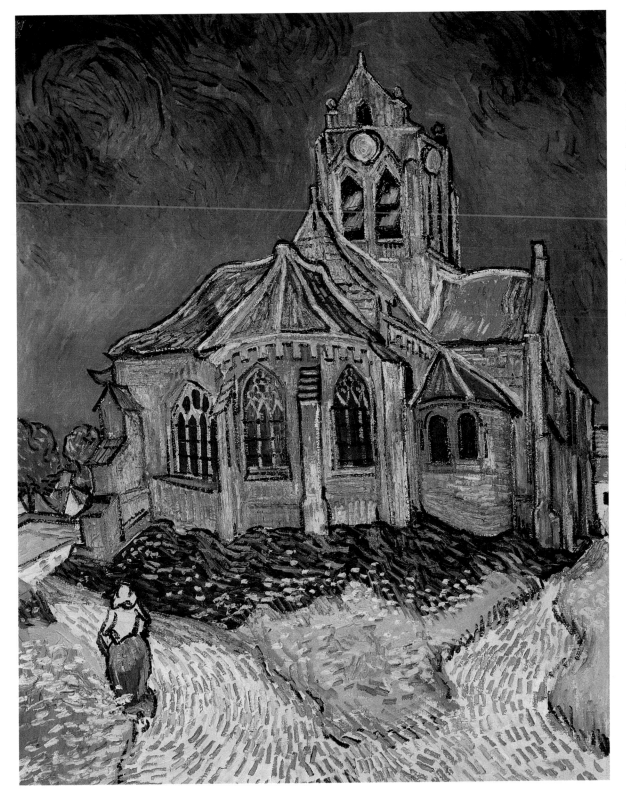

The Church at Auvers-sur-Oise, June 1890.
Musée d'Orsay, Paris.
Apart from these I have a larger picture of the village church — an effect in which the building appears to be violet-hued against a sky of a simple deep blue color, pure cobalt; the stained-glass windows appear as ultramarine blotches, the roof is violet and partly orange.
To his sister, June 1890.

The banks of the Oise. *Sunday has left me a very pleasant memory; in this way we feel that we are not so far from one another, and I hope that we shall often see each other again.* To Theo and Jo, June 10, 1890.

that he thought he would one day paint his portrait, which he did. There are several paintings of the doctor.

First of all, he turned his attention to landscape, which is easier because there is no need to ask the model politely to pose. He liked to paint from nature. That was the great triumph of the nineteenth-century avant-garde, from the time of Corot and the painters from the Barbizon school. Impressionism captured nature so gloriously well. Placing oneself in front of the subject and extracting a painting from it, a painting that is part nature and part art, a painted image of the scene but something much more—a work of art, the singular work of a unique artist. He painted the thatched

cottages, sketched an old vine, and did studies of chestnut trees. "Studies"—that was how he normally referred to the works that are today considered to be perfectly completed masterpieces—and they were canvases brushed hastily from life one after the other, quickly, always very quickly, because Vincent was in a hurry, and especially because the paintings presented themselves to him at great speed. Then he was able to write to his brother: "I'm working at his portrait, the head with a white cap, very fair, very light, the hands also a light flesh color and cobalt-blue background, leaning on a red table, on which are a yellow book and foxglove plant with purple flowers." And his mind was already busy with other por-

traits, those of the doctor's daughter, of Theo, Jo, and others, but he would need models, and it was never easy to find models. Perhaps Dr. Gachet would help him to find some models. Maybe people would even pay him to do their portrait so that he would be less dependent on Theo for money.

In Auvers, the portrait was the essential thing. "What I am most interested in, much more than anything else in this profession, is the portrait, the modern portrait."

The portrait made with pure color. In other words, he was not too concerned with photographic resemblance. Later, in a letter he wrote to his sister, he said:

"I did a portrait of Dr. Gachet with an expression of melancholy, which would seem to look like a grimace to many who saw the canvas. And yet it is necessary to paint it like this, for otherwise one could not get an idea of the extent to which, in comparison with the calmness of the old portraits,

Blossoming Chestnut Branches, Auvers-sur-Oise, May 1890. Collection Bührle, Zurich.

OVERLEAF
Wheatfield with Crows, Auvers-sur-Oise, July 1890.
Rijksmuseum Vincent Van Gogh, Amsterdam.
They are vast fields of wheat under troubled skies, and I did not need to go out of my way to try to express sadness and extreme loneliness.
To Theo and Jo, July 1890.

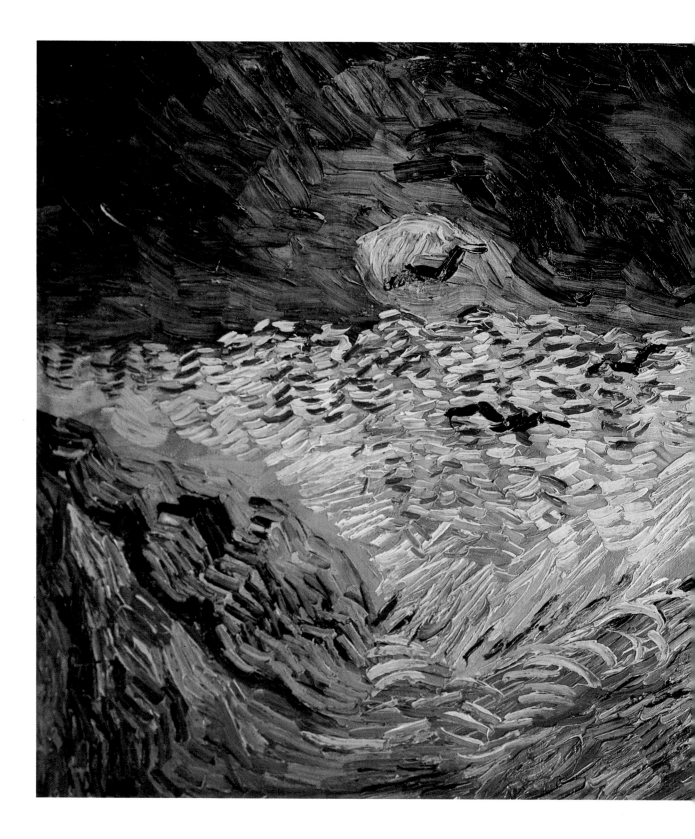

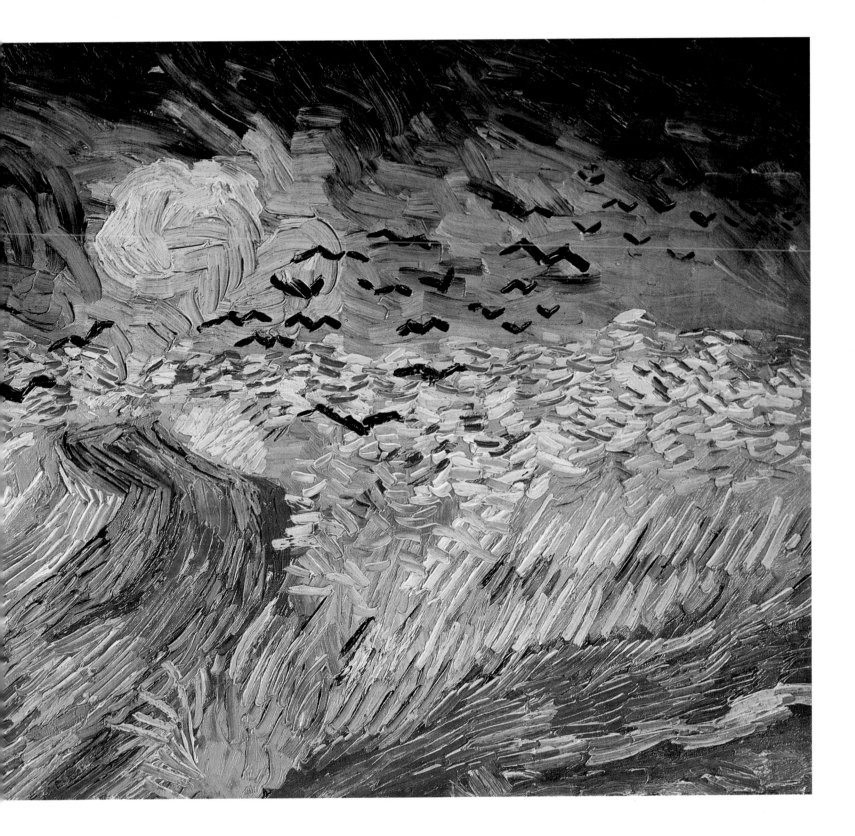

Sunlight and shade
at Auvers-sur-Oise.

there is expression in our modern heads, and passion—like a waiting for things as well as a growth."

Painting is the essential thing. Painting will always be the essential thing—to paint today, in the style of today, a style that shows people as they are now. Art, however, cannot be reduced to capturing the current moment according to the rules of Impressionism. In another letter to his sister praising Puvis de Chavannes and a painting by him that Vincent had seen in Paris, he expressed what he thought was the quintessential art: "all humanity, all nature simplified." He added that "one gets the feeling of being present at a rebirth, total but benevolent, of all the things one should have believed in, should have wished for—a strange and happy meeting of very distant

antiquities and crude modernity." A few days later, he confided to his mother that painting was not "just the process of manufacturing images, representing things we see: it is creation, the building of a world; a poetic and spiritual adventure." Vincent painted incessantly. He painted bouquets of flowers—irises, roses—landscapes. He painted the town hall, the church, the château at Auvers

among the trees, among the wheatfields; the fields in light rain, a landscape with vine, a field of green wheat. Van Gogh's painting is not so much images of the world or simply images of Auvers, Arles, Paris, the Borinage, Brabant; it is an insight into another dimension parallel to the world from which he drew his inspiration. In this way we can say that all Van Gogh's paintings, whether landscapes or portraits, are to some extent self-portraits.

Vincent wrote many long letters from Auvers, mostly to his brother Theo, with whom he had corresponded for many years. They carried on a continuous conversation from a distance. The painter told the art dealer, his friend and patron, everything he did and what he was in the process of painting. He felt obliged to keep Theo informed, as he considered that they had an arrangement, that they were partners. It was Theo's financial support that allowed Vincent to paint at all, and therefore his progress was of mutual concern to them both. Vincent also told Theo all the things he could not tell anyone in Auvers, because those who were not painters themselves could not possibly understand, and those who were painters did not seem to share his

concerns, but were content to paint in the old style, to carry on the traditions of their predecessors. Day after day he honed his own theory of painting, distancing himself by degrees from Impressionism, steering the history of modern painting in his direction, projecting the art of his dreams into the future.

The man who emerges from the pages of this correspondence is a prodigious writer, an unrivaled art critic, and a marvelously cultured man. From the time of his trip to London when he made the break from his career as an art dealer seven years previously, when the balance of his mind first became disturbed, we can follow the path of his intellectual development and artistic triumph quite accurately by way of these letters. If we add to them the accounts of a few eyewitnesses, we can relive with him his last weeks, the seventy days he spent in Auvers, even though he wrote fewer letters to Theo in this period than before. Theo was now married and had an infant son, yet another Vincent Willem Van Gogh, and had less time available for Vincent, whose anxiety was mounting over his finances and his work. Money was tight, and he was suffering from nervous exhaustion. He was also feeling guilty about being a continual drain on the resources of his brother's new family. He felt that it would be better for all concerned if he left; went far away, farther even than Arles, to a country where he could exist on much less than in Auvers. He thought of following Gauguin to Tonbi in Madagascar since as he said, strangely enough, "the Future of painting is in the tropics." He was all too aware that in the light of his poor health and even poorer financial situation, it was an impossible dream. His best hope was that their paintings would be bought by a few art enthusi-

asts, that they would find a few buyers in Paris. Gauguin was preparing to return to Brittany, and since Vincent now felt freed of what he had described as "South sickness," that series of mental crises that had exhausted him at Arles, he felt inclined to spend a month or two in Brittany, painting seascapes. He thought about it, but it was too late.

Apart from a few canvases at Saintes-Maries, Vincent had done few paintings of the sea. In fact, unlike most of the Impressionists, he had painted very few pictures of water. Even at Auvers he hardly ever went down to the banks of the river. He was drawn more toward the land, to the high part of the village and to the wheatfields. "I am trying to do some studies of wheat like this, but I cannot draw it," he wrote to Gauguin: "nothing but ears of wheat with green-blue stalks, long leaves like ribbons of green shot with pink, ears that are just turning yellow-edged with the pale pink of the dusty bloom—a pink bindweed at the bottom twisted round a stem." But that was only a background, as in those paintings of Millet which he had interpreted at Saint-Rémy, "a lively and yet peaceful background" on which he wanted to paint portraits, always portraits. He painted portraits of Dr. Gachet, with his 'heart-broken expression of our time," the daughter of the Ravoux, the daughter of Dr. Gachet, a peasant woman, but they were still not enough for him and so on he worked. Vincent said that he "was working hard," all the more so because he now felt alone. His dream of founding with Gauguin a community of artists who would help each other, "the atelier du Midi" had failed. He sensed that Theo was finding it increasingly difficult to play his role of committed patron. He also understood that he

could not put pressure on the already fragile Dr. Gachet. And, of course, his paintings were still not selling. "I feel a 'failure,' he wrote to Theo at the beginning of July. Then, in another letter, he went on to say that he felt his life was "threatened at the very root." This was after a brief stay in Paris where they had reviewed the situation and shared their modest expectations.

One Sunday, Theo, Jo, and the little Vincent came to Auvers. The weather was fine. They had lunch at Dr. Gachet's house. They were all happy. The small boy was amazed at the wildlife in the doctor's garden. They went for a long walk. They had a glimpse of life as it should always be, warm and carefree. Vincent wondered if this was what it would be like if they all lived together at Auvers. It was the beginning of June. A month later, Vincent went to spend a Sunday in Paris, and that elusive sensation of shared happiness was gone. His young nephew had been very ill, and Theo and Jo

OPPOSITE

Daubigny's garden.

Here one is far enough from Paris for it to be the real country, but nevertheless how changed it is since Daubigny. But not changed in an unpleasant way; there are many cottages and various modern middle-class dwellings very radiant and sunny and covered with flowers.

To Theo and Jo, May 1890.

OVERLEAF

Daubigny's Garden, 1890. Musée Historique des Beaux Arts, Basle.

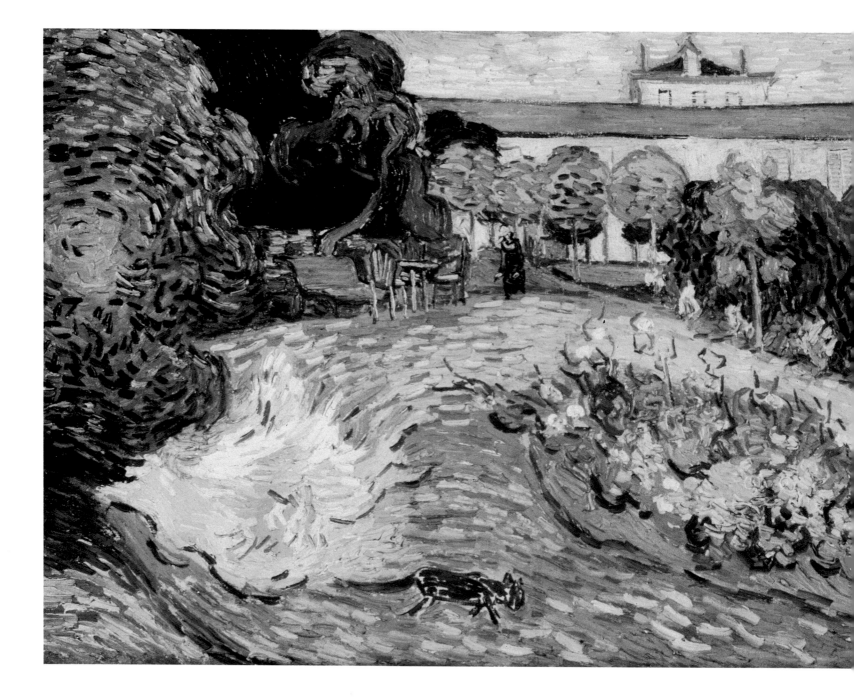

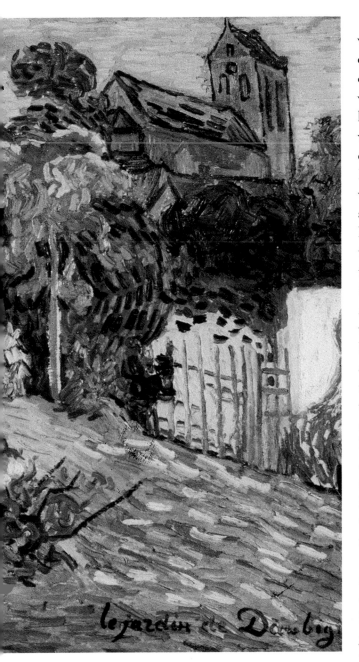

were tired. Theo was suffering from nervous exhaustion and was finding it difficult enough to carry out his responsibilities as head of the family without the added burden of his commitment to his brother. His employers, Boussod & Valadon, were not overly generous and showed little interest in the efforts he made in promoting the Impressionists who, frankly, were not popular with art-buyers. He was tempted to walk out and slam the door, and take the risk of working for himself. By the end of the afternoon, Vincent felt the need to leave the stifling atmosphere, to return to Auvers, to his solitude and his painting. Something was broken. What was lost was hope. A storm was threatening. Vincent was worried. He was no longer certain that he could count on his brother's continued financial support and he was anxious about the trip that Theo and Jo proposed to make to Holland to visit his mother. Whether it was the timing in view of the recent illness of the child or the expense, we do not know for certain, but Vincent was not in favor of this trip. The letter Jo wrote to her brother-in-law, on July 9th, was not reassurance enough for him. She said in it, however, that the sad period was over, that there was no need to worry; Theo and Jo were both there, at his side.

Vincent now lived solely for painting. He was depressed and sad. He was afraid for the future in case his illness would return. He made no plans beyond the age of forty, which was only three years away. He immersed himself in painting and produced three major works ("vast fields of wheat under troubled skies, and I did not need to go out of my way to express sadness and extreme loneliness") and *Daubigny's Garden*, which had been in his mind since he arrived in Auvers, a painting that

would express a completely different feeling for nature, nature inhabited by man. This painting shows a feeling for the sweetness of life that is evident in the work of Corot. "But for one's health, as you say, it is very necessary to work in the garden and to see the flowers growing," he wrote to his mother and sister at home in Holland. In this letter, he also describes the wheatfields: "I am entirely absorbed by this infinite expanse of wheatfields with a background of hills as vast as the sea, delicate yellow, delicate soft green, the delicate violet of a dug-up and weeded piece of soil, checkered at regular intervals with the green of flowering potato plants, everything under a sky of delicate blue, white, pink, violet tones."

The very least that can be said is that Vincent never lost hope in the world, that he loved it intensely, but that he suffered because he himself was not more in harmony with the great beauty of nature that he praised continually. After the sentence we have just quoted, Vincent wrote the following, which seems strange coming from someone who legend has it was impassioned, hallucinated: "I am in a mood of almost too much calmness, in the mood to paint this."

Vincent too calm? Can this be the calm before the storm? The cold detachment of a man cut off from the world, a broken man, too clear-sighted to commune with nature or to devote himself entirely to painting. This lassitude showed in his last letter to Theo:

"There are many things I should like to write you about, but I feel it is useless."

All that is left of those last days is *Daubigny's Garden*, sketched in the same letter—a beautiful painting that expresses a certain joy at being in the world, a serene harmony between nature and

painting. The drawing is accompanied by a cold, purely descriptive commentary that specifies the colors: "*Daubigny's Garden*, foreground of grass in green and pink. To the left a green and lilac bush and the stem of a plant with whitish leaves. In the middle a border of roses, to the right a wicket, a wall, and above the wall a hazel tree with violet foliage. Then a lilac hedge, a row of rounded yellow lime trees, the house itself in the background, pink, with a roof of bluish tiles. A bench and three chairs, a figure in black with a yellow hat and in the foreground a black cat. Sky pale green."

He had given a great deal of thought to this painting and took the trouble to describe it precisely and in great detail to his brother. There are two versions of this work, which he described himself as one of the paintings he had been most compelled to do. It must therefore be accorded the value of a manifesto of Van Gogh at Auvers. This thirty-seven-year-old artist in the prime of life, at the peak of his talents, but so close to death. That painting was certainly not the painting of an anguished artist, of a man at the end of his endurance, a madman, or a fanatic. It is a painting full of harmony, pastoral calm, of great sensitivity, of course, with the thick but vibrant brushstrokes that became Vincent's trademark; his style that illustrates so well the movement of animate objects, and the constructed order of architecture. This is the last work he refers to in any correspondence.

Daubigny's garden.
But for one's health, as you say, it is very necessary to work in the garden and to see the flowers growing.
To his mother and sister, July 1890.

OVERLEAF
Field near Auvers,
Auvers-sur-Oise, June 1890. Kunsthistoriches Museum, Nouvelle Galerie, Vienna.

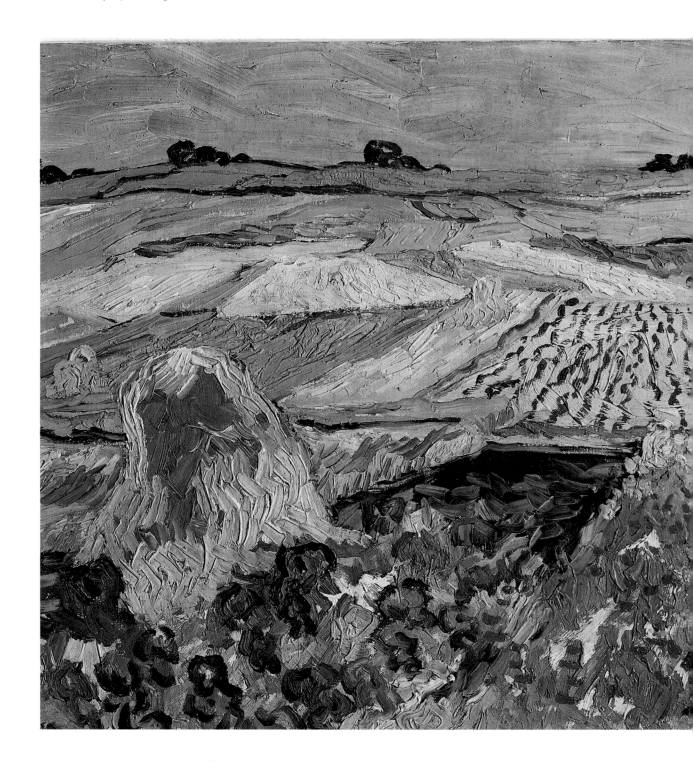

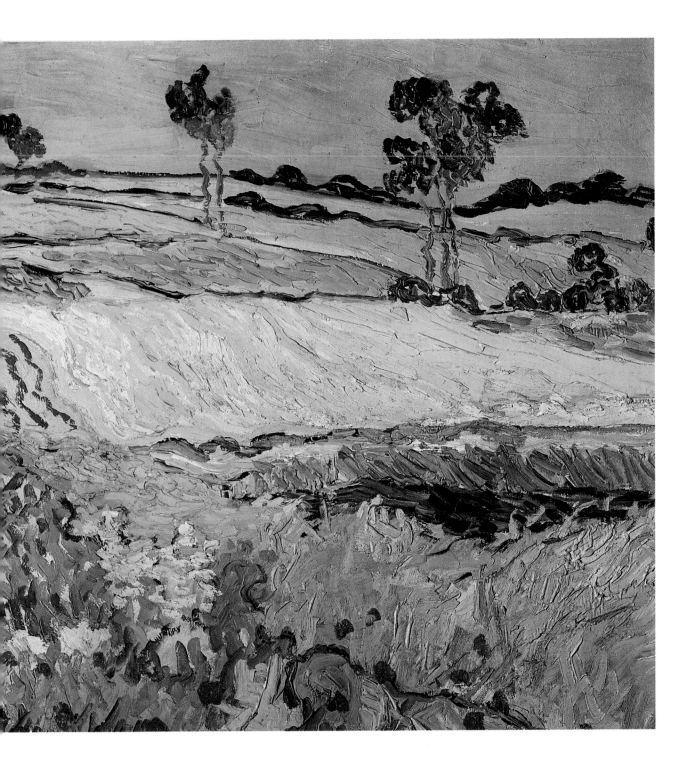

But what of the *Wheatfield with Crows?* It has often been wrongly considered his ultimate painting because it seems to convey tragedy. However, it cannot possibly be taken as Vincent's swan song for the very simple reason that the wheat has not yet been cut. The artist took his life on July 27th, after the harvest. Other paintings, where the haystacks are visible, confirm this fact, notably with *Wheat Field at Auvers Under a Cloudy Sky*, an admirable painting of great serenity, intelligent composition, a subtle interplay of greens, blues, and yellows, with the foreground sparsely punctuated with the red of a few poppies. In the last letter sent jointly to Theo and Jo, following the letter Jo had sent to him, Vincent refers to two paintings painted prior to *Daubigny's Garden*. "These vast fields of wheat under troubled skies, and I did not have to go out of my way to express extreme loneliness." This was wheat before the harvest, as if threatened by the storm, over which the crows are flying. These canvases, painted at this time of trouble at the beginning of July, after the last visit to Paris, in fact his last paintings before he died, prove that Vincent had overcome the depressive episode and had found his equilibrium in painting again. Which begs the question of why did he kill himself? No one can answer that question. Is it ever possible to know why someone takes his own life? Why suddenly he seems to reach the point where there appears to be no future or at least no future of which he could be a part. For Van Gogh's painting, he knew, did have a future in front of it. Perhaps he died to make way for it, because it no longer had any need of him. Perhaps he killed himself in Auvers because he had found the North again. He had come full circle.

In the wheatfield, after the harvest, he took his

life somewhere behind the Château d'Auvers. He had bought a gun in Pontoise. He took it with him when he headed back out to paint in the open air after lunching at the Ravoux inn on Sunday, July 27th. He came back home late in the evening, wounded, shaking. He lay in his room in agony. The doctors—Dr. Mazery, who practiced in Auvers, and Dr. Gachet—together decided that nothing could be done for him. The night was peaceful. In the middle of the next day, Theo arrived at his brother's bedside. Vincent was still conscious. They exchanged a few words and later that evening, when his breathing became labored, it was obvious that Vincent was going to die. He died on July 29th, at 1:30 am. In the pocket of his jacket was a letter addressed to his brother, which he had not had time to post. It was a letter that perhaps he intended to be taken as a sort of last will and testament. He said in it, in the present tense: "Well, my own work, I am risking my life for it and my reason has half floundered because of it." He made no reference to the definitive act that was to bring his existence to an end. In that letter he wrote the most beautiful sentence on which the life of a painter who had written so much about painting, and about whom so much was yet to be written, could end: "Well, the truth is, we can only make our pictures speak."

The Ravoux inn and Auvers-sur-Oise entered at that moment into history. The room on the ground floor where Vincent had worked and where he left his canvases to dry was transformed into a mortuary. The coffin was placed on trestles. The easel, palette, and brushes were placed in front of it and the walls were adorned with his paintings. The village people came here to pay their respect, and since the priest had made it clear that the church wanted nothing to do with suicides, its hearse was

not available to him. One was borrowed from a neighboring hamlet. Friends, painters came from Paris, including Père Tanguy, who sold paints and Impressionist paintings, a communard and sympathizer with avant-garde painters, who was one of Van Gogh's staunchest defenders. Émile Bernard, the painter from Pont-Aven, a friend of Gauguin, the wise artist who recognized early on that modern, Post-Impressionist painting was emerging in the confluence of Cézanne, Gauguin, and Van Gogh. And a few others came too. The sun was shining in a cloudless sky and the heat was

For myself, I can only say at the moment that I think we all need rest—I feel exhausted. So much for me—I feel that this is the lot which I accept and which will not change.

To Theo and Jo, July 1890.

Well the truth is, we can only make our pictures speak.
To Theo (letter that Vincent had on him on July 29, 1890, when he died). (Note on the letter in Theo's handwriting, "Letter found on him on July 29th.")

terrible. The funeral procession came out of the inn that Vincent had painted, to the square in front of the Town Hall that Vincent had painted, passed in front of the church that Vincent had painted, went up the road and reached the cemetery. Vincent was buried at the foot of a wall. Few people present were fully aware that a great artist had just died. This generous man had loved nature and his fellow men beyond all reason. It is true he had not always been an easy character. He was often bizarre and sometimes subject to violent anger, but he was so immersed in his painting and dreams of a better world where artists could live and be creative without being condemned to poverty. Theo cried, and he was not the only one. Through his tears, Gachet could not deliver the eulogy that he had planned. Theo cried, and he did not know that he would be dead within six months, and that he also would be buried alongside his brother in the same cemetery. People come from all over the world to Auvers-sur-Oise and stand in front of these two simple graves that are nestled in the ivy that Vincent loved so much, and they wander through the streets of Auvers, or go into the room at the Ravoux inn—that empty, basic attic, preserved as if he had just left it. These historic monuments resound with the loss of Vincent Van Gogh.

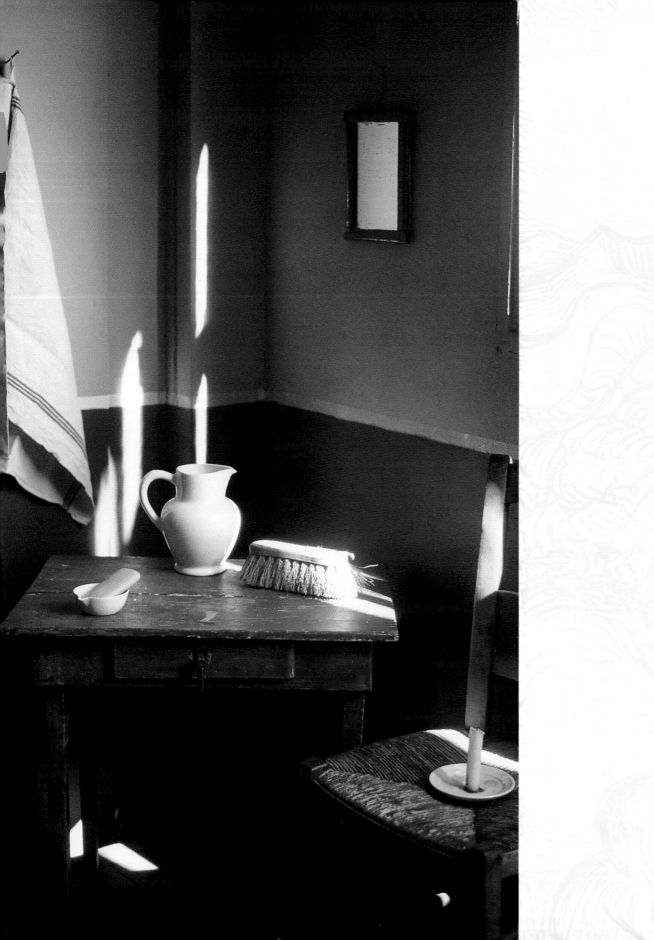

The Dream of an Artists' Community

When you come out of the station at Arles and walk straight toward the nearby river Rhône, you will find yourself standing below two large lions overlooking the river. They stand there proudly above the wide bend in the river that flows toward the old town. Facing them on the other side of the river is an identical pair of lions at exactly the same height. This was the site of a railway bridge that has now been destroyed. Vincent Van Gogh painted that bridge, which carried trainloads of passengers to the countryside. The river bank is wild, overgrown with weeds and strangely resistant to any attempts at urbanization. If you take the few small steps up to the terrace and look along the line of the river, there is a splendid view of Arles at sunset. The brown of the distant walls, the grays that have a slightly ochre hue, the green of the river sliding down between the deserted banks to the sea, and the arc of a halo in the sky above the town all convey a sense of calm. The flowing river is accompanied on its way by the wind, called the mistral. Vincent lived just a short distance away and from this spot, or somewhere close to it, he painted Arles by night, under the stars.

The connection between Van Gogh and the Hotel Terminus in Arles is only an illusion of remembrance. Although proud to have been built on the same spot in Lamartine Square, it has not inherited the magic that is still associated with the Yellow House. The original house had a double frontage. Vincent occupied the right-hand side, and the other half was a restaurant where he usually took his meals, when he ate meals at all. That was where he received Gauguin, when poverty united them in the same exile in Provence, but supported by the good Theo, the thoughtful patron of these two artists who were

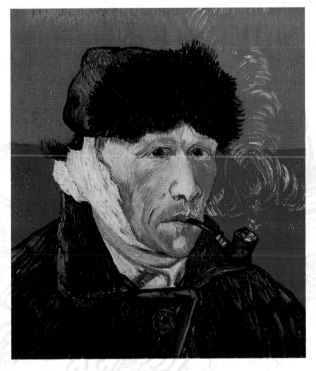

Self-Portrait with Pipe and Bandaged Ear, Arles, January 1889. Private collection.

And as for the causes and consequences of said illness, I think I shall be wise to leave the solving of these problems to the fortuitous discussions of the Dutch catechists, that is to say whether I am mad or not, or whether I have been mad, and am still mad [...] whether I was already mad before that time; or whether I am so at present, or shall be so in the hereafter.

To Koning, January 1888.

OVERLEAF

The Rhône, at Arles.

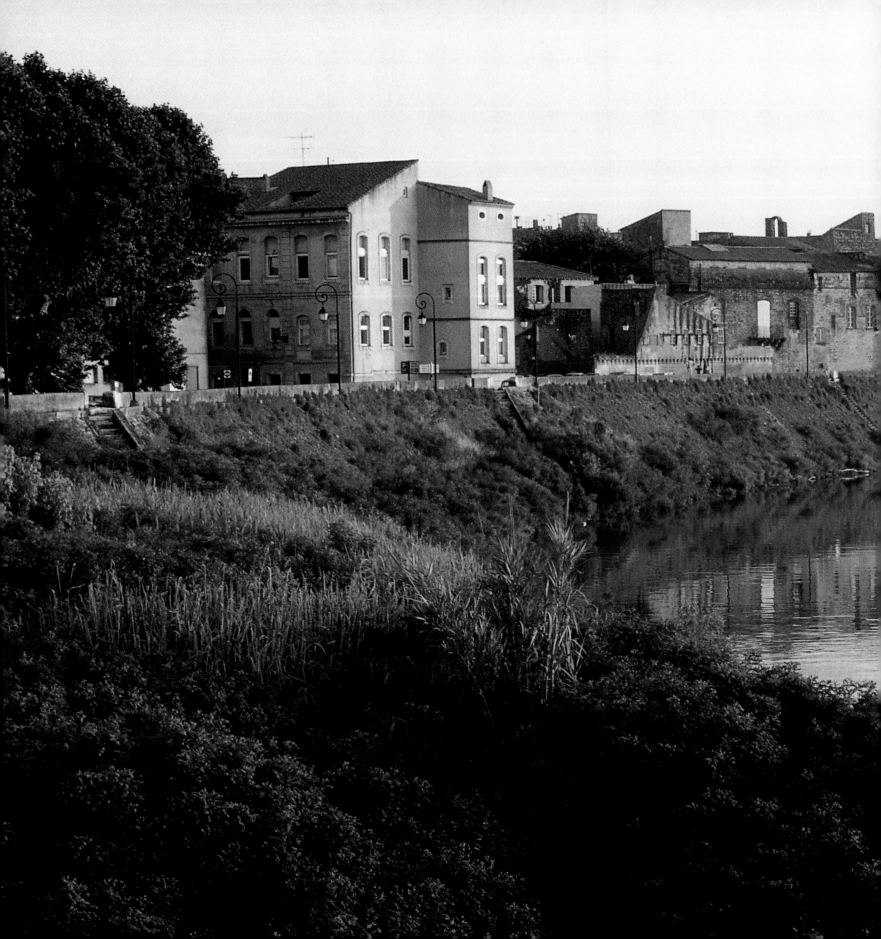

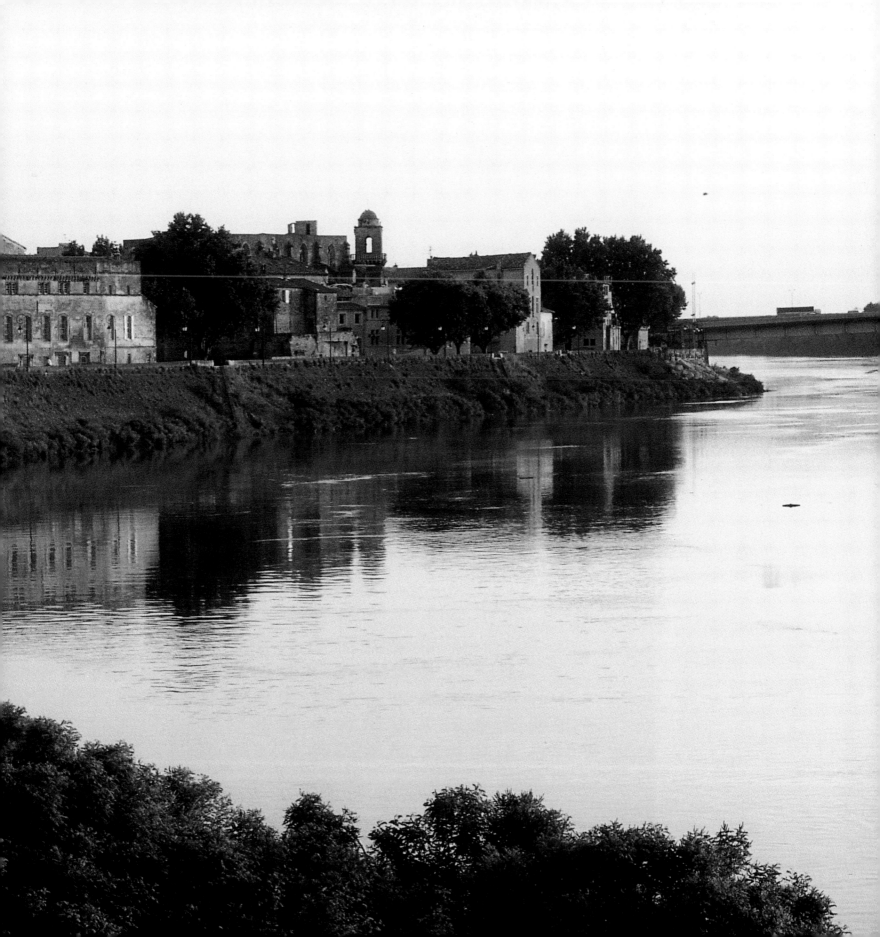

yet to achieve greatness. The house was bombed during World War II, and hardly a trace remains except a few meager photographs showing a banal façade, but only one painting exists as sole proof of the great dream of the Atelier du Midi. Irritated by the habits of the Parisian art set, the hypocrisy of the art market, and the wiles of art critics, Vincent dreamed of setting up a fraternal community dedicated to the advancement of art—a sort of socialist utopia of painting. Young painters now come from all over the world to sleep here in the hope that the aura of genius of the place will somehow define them. The rooms are not very expensive, even if inspiration is not guaranteed. The Café de la Gare or station café has also disappeared—that friendly establishment where Vincent came to escape his loneliness in the company of the postman Roulin. He was not really a postman as such, but a clerk in the dispatch department of the post office. They no doubt met one day when Vincent

OPPOSITE

Langlois Bridge.

BELOW

Place du Forum.

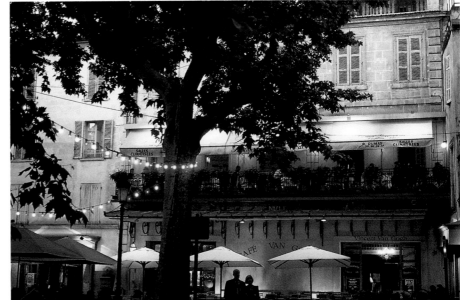

took a parcel of rolled canvases to send to Theo. He sent his paintings regularly to prove that he was actually working and to show Theo how his painting was progressing in the hope that Theo could try to sell some of his paintings.

The lion is the guardian spirit of Arles. There are lions everywhere: on the fountain in Place de la République, on both sides of the main staircase at the town hall, at the porch of Saint-Trophime, as gargoyles atop the columns of the cloisters, or above the door of the Réattu Museum. They all have a sort of regal air—serene, not ferocious. But

The Saint-Trophime cloister at Arles.

There is a Gothic portico here that I am beginning to think admirable, the porch of St. Trophime.

To Theo, March 1888.

OPPOSITE

In a street in Arles.

anyone familiar with this territorial animal knows that it is placid only when it feels assured, and it should never be riled. It has a quick temper with boundless anger, and the motto of Arles refers to this: *Ab ira leonis* (by the anger of the lion). Vincent learned at his expense that Arles rejects those who do not win it over. He did not have an attractive bearing, for he looked like an undernourished artist with his devouring passion for painting, his hallucinated eyes, his ginger Nordic beard, his tramp's clothes; and he talked like a delirious anarchist in his irritated loneliness and his excited painting. He had a few friends: Roulin, the socialist who preferred bohemians to the bourgeois; pastor Frédéric Salles who was generous and respected the noble in spirit; Félix Rey, a young doctor who was not bound by psychiatric prejudices. He also had enemies, at least the signatories of a petition sent to the mayor to ask him to commit to an asylum this scandalous man who sliced his ear and delivered it like a box of sweets to the woman whose favors he usually paid for in the brothel where he was an habitué. Rachel, whose name was really Gaby, did not complain about him. She fainted, then gave the ear (or the part of the ear; it is not really known exactly what he cut, for the stories differ) to the marshal who had to establish the official report and perform an inquiry on a news item that was as strange as it was regrettable. But above all, even more cruel, was the indifference with which his painting was received. He knew his painting was the carrier of a new warmth; it showed a new light and it expressed love of the world and of life. From time to time he had doubts, claiming that he was only a modest innovator. He emphasized the importance of Gauguin's role, but in spite of this, most of the time he had in his heart of hearts a true idea of what he

was actually in the process of doing. The reservations he expressed came mostly from the gulf between the grandeur and intensity of his imagination and the quality of his paintings as he perceived them. His eye to hand reflex was slow. Brushes could not keep pace with his ambition. He ruined his health by painting continuously, without respite. He must have known that he would not live long and was afraid he would run out of time.

Vincent did not like towns. He didn't really live in Arles itself. He had not found very many subjects actually within Amsterdam, The Hague, Antwerp, or Brussels. He looked more for landscape, nature, people of the land, peasants or miners. He had known Paris, but had only really painted the outskirts of the city: Montmartre and Asnières for example. The beauty or history of Arles are hardly mentioned in his letters. Truthfully, he was not really a storyteller and little given to description if it did not involve painting, or give him an opportunity to speak about painting. Arles was the base camp, with the Yellow House, the Atelier du Midi, a roof over his head, a room to paint in when the weather was poor, cafés where he could spend an evening, girls he could pay, companions for exchanging a few words while draining a glass of wine or a cup of coffee. It is, however, difficult to imagine that he did not wander through the streets between the Rhône and the arenas, the Méjean and the amphitheater, between the Place du Forum and the Hotel d'Arlatan, on the quay Saint-Martin now called Marx-Dormoy, where Charles Nègre had photographed a pontoon bridge in 1854. Did he never go into the Saint-Trophime cloister where the splendor is so exactly on a human scale, where the grotesque caricatures lined up at the tops of the

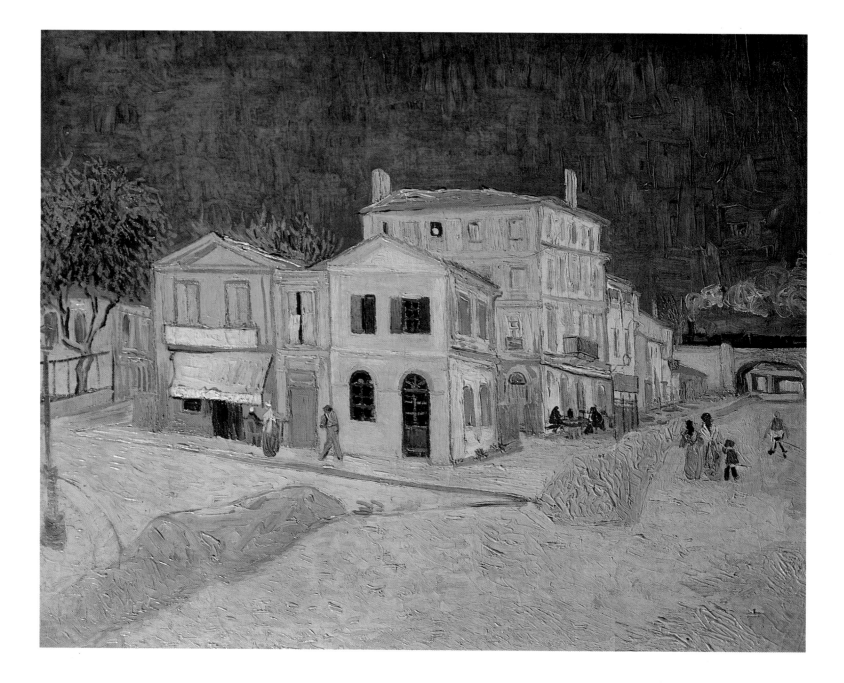

columns would surely have amused him? But he needed open air, trees, blue and yellow, nature, or night time in which the detail of the town is lost, where everything—town, architecture, café—is nothing but shadow and light defined with pure color.

It is also difficult to imagine that he did not walk along Rue du Refuge, Rue des Baptêmes, Rue du Jeu-de-Paume, Rue de la Bastille, Rue du Sauvage, Rue de la Trouille. Most of them have changed their names. Today, he would go through Place Nina-Berberova, from the name of a great Russian novelist. He would go into the Réattu Museum, which is no longer the antiquated gallery that made him shrug his shoulders. He would take a long, fraternal look at the drawings of Picasso. Perhaps, in too much of a hurry, he wouldn't stop in front of some paintings by Jacques Réattu (1760–1833), no doubt too academic for his taste, timid, limited in scope, but this would be a mistake. Even the greatest can make mistakes; for it is wrong to ignore minor works in which one might find some qualities when viewed with an open mind. Look, for example, at *The Artist and His Family with a Red Umbrella*, painted in 1821, which

shows four characters in profile in a curious triangle the apex of which is held by the painter with a card placed on his knees, the sketch that shows a man standing wearing a large hat, a woman seated with a book, another with a child in the fold of her right arm who is the only one who seems to be moving. This living maternity is totally ignored by the painter who is absorbed in his work. Painting, Réattu shows here, is a strange business, a solitary pursuit that can also allow you to paint *The Sun* showing a woman's face with curly hair piled up on the head and wide blue eyes.

Today, at this museum Van Gogh would be able to see the astonishing painting by Antoine Raspal (1730-1811) with an almost identical title: *The Painter's Family*. The painter has done a portrait of a young woman. The model for the portrait is present in the tableau, toothless and unsmiling and a few decades older than she appears in the portrait, while another younger woman who bears some resemblance to her is standing behind the painter and looking over his shoulder. She is holding a ball of wool in her left hand, and the end of the wool is in her right hand at hip level. There is nothing heroic-looking about the artist himself. He is bald-

*L'Arlésienne: Madame Ginoux
with Books,*
Arles, November 1888.
The Metropolitan Museum
of Art, New York.
*For I suppose that all at once I
shall make a furious onslaught
on the figure, which I seem to be
giving a wide berth at the
moment, as if I were not
interested in it, although it is
what I really aim at.*
To Koning, June 1888.

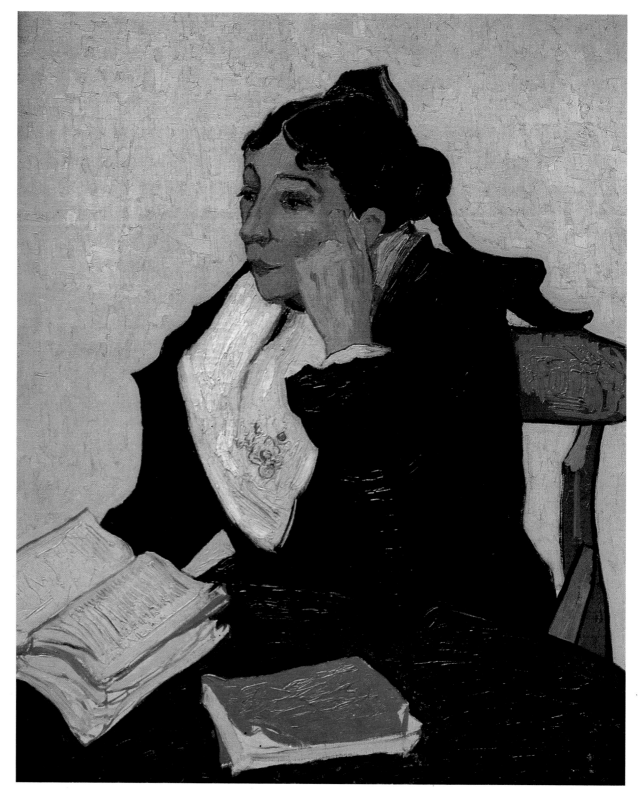

ing and slightly deformed, with red cheeks. He has a pleasant but not really attractive appearance. The face is turned towards us with an affectionate look in the eyes, his thumb stuck firmly through the palette, holding a whole fistful of brushes.

Van Gogh painted *La Berceuse* in Arles. It was, in fact, a portrait of Madame Roulin, the wife of the postman. The title is the painter's own. In this instance, we are sure because he wrote it on the painting himself, beside the signature that he had reduced to his first name only. He did four versions of this painting. The word berceuse (or lullaby), does not refer here to a song, but to the woman rocking the cradle. She is holding in her hand a cord that you have to imagine is connected to a cradle to make the rocking movement babies find so soothing; a cord whose upper point is hidden, apparently marked by the ring on the left ring finger, and with the hands placed on her abdomen over the navel, as if, from one cord to another, Vincent Van Gogh was acknowledging the influence of the French painter Antoine Raspal.

Madame Roulin was a well-built matronly woman whom Gauguin also painted when he came to join Vincent in Arles. She had a generous bosom, a round face, and hair piled high up on her head. A woman and mother, she accepted Van Gogh as he was. She dutifully kept her house while her husband stayed late at the café with the painter. To Vincent, the Roulins were the epitome of a united couple, with the kind of peaceful household he would have wanted himself, and had tried to establish in Holland with Christine, the prostitute he tried to save from the streets of The Hague. A home like the one he had known with his own family, his father and mother, brothers and sisters. He realized that this was now beyond the grasp of this poor painter, condemned as he was to solitude.

The way the women dress is pretty, and especially on Sundays one sees some very naïve and well-chosen combinations of colors on the boulevard. And no doubt this will become even gayer in summer.
To Émile Bernard, March 1888.

Although he did not have love, at least he still believed in friendship. It was for this reason that he wanted to start a workshop, the Atelier du Midi in Arles, eagerly welcoming Paul Gauguin, whom Theo had saved from almost starving to death in Brittany. Together, assisting each other, life would be easier and less expensive, and so Vincent set up the Yellow House on Lamartine Square after leaving the restaurant Carrel in Rue de la Cavalerie, where he lived when he first arrived in Arles. He had been cheated there to the extent that some of his personal belongings were kept in lieu of sums he did not owe. Luckily, the law found in his favor in this dispute. He spent a few months, from May

to September 1888, at the Café de la Gare, run by the Ginoux. The café was also situated on Lamartine Square, which had been the center of Vincent's life in Arles, but was destroyed during World War II. No doubt he had already frequented this establishment that, like a few others, stayed open at night to receive both the night birds looking for pleasure and those simply seeking shelter. He did a portrait of Madame Ginoux, who had a less maternal demeanor than Madame Roulin and with sharper features, but still had the beautiful dignity of an Arlésienne in her traditional costume. He brushed the portrait in less than an hour and then did another version giving more intensity to the color, especially the yellow background and the black of the hair and the shawl, replacing a parasol and gloves by three books. He also did a strange painting called *Café de la Gare* on a theme that the Impressionists had already done in Paris. In this rare example of an interior scene two men are falling asleep at a table while a couple in the back are chatting. A man in white is standing close to the billiard table in the center that is illuminated by four lamps, the stark light from which is suggested by long brushstrokes. On August 6th, Vincent announced to Theo that he was going to begin this painting. On September 8th, he told him he had just spent three nights working on it. "I have tried to express the terrible passions of humanity by means of red and green." He immediately copied it in watercolor to show to his brother.

In the center of the town there was another café, on Place du Forum, which was then called Place des Hommes. The war did not cause a great deal of damage to this part of the town. No doubt the station was the target and the old town of Arles held good. The café still exists, proud of its pictorial past, decorated in a marriage of blue and

yellow in honor of Vincent, and now christened the Café de Nuit, as in the painting that made it famous and about which the artist said "it is a night painting with no black." One of its neighbors has subtly acquired the name of Le Tambourin, after a café Vincent frequented in Avenue de Clichy in Paris. By day or night, the center of the square is taken over by the tables from the various establishments around it, and it is the high spot of social life in Arles. The high statue of Frédéric Mistral, the great poet of Provence, dominates the scene.

Vincent painted the town relatively little, although it is not lacking in picturesque monuments from different eras such as old hotels, relics of the Roman occupation, and winding lanes. It also has elegant and popular quarters. He painted the Yellow House, with a train passing in the background. He painted the railway bridge, the bridge with the lions that has since been destroyed, and the Trinquetaille bridge that has also been replaced, but the old staircase remains more or less

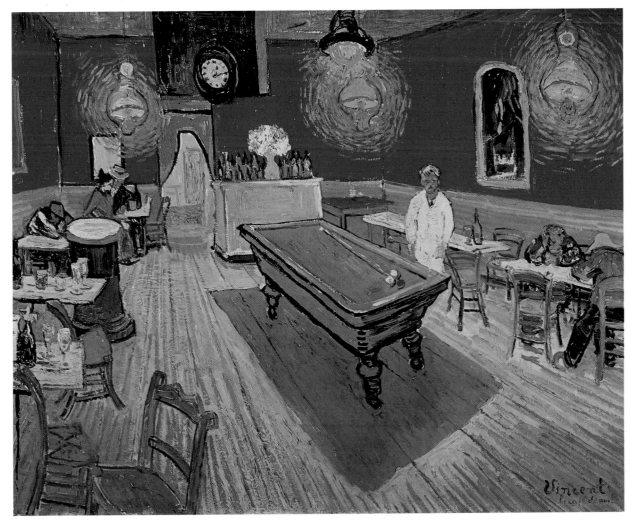

The Night Café, Place Lamartine, Arles, September 1888.
Yale University Art Gallery, New Haven.
In my picture of Night Café I have tried to express the idea that the café is a place where one can ruin oneself, go mad, or commit a crime.
To Theo, September 1888.

OPPOSITE
Café at the Place du Forum, drawing, Arles, September 1888. Collection of Wendy and Emery Rivers, the Dallas Museum of Art, Dallas.

as it was when Vincent saw it. He painted some on the banks of the Rhône, showing its sand barges on green water and coal barges in the sunset. He painted the garden on the Boulevard des Lices with its tall trees and where almost a century later a stone bust was erected as a memorial. He painted neither the ancient theater nor the arenas except for one very quick sketch of the crowd, but not the monument itself. He did not paint Saint-Trophime or the Hôtel d'Arlatan, which in the 15th century was the residence of the Counts of Arlatan de Beaumont. He largely ignored the places of architectural significance—the Notre-Dame-de-la-Major that was consecrated in the year 455 on the occasion of the third council of Arles by Ravennius, the Bishop of Arles, assisted by thirty-four other bishops; the Réattu Museum that stands so proudly on the Rhône; the Hôtel Sainte-Luce where today there is a blue cart, like the one he painted, recently donated to the town of Arles. Of the hospital in which he gained the friendship of Dr. Rey, the intern who cared for him, he painted

Mosaic
on a house in Arles.
Opposite
Statue of Frederic Mistral
on Place du Forum.
These Félibres *are a literary
and artistic society, Clovis
Hughes, Mistral, and others,
who write fairly good,
sometimes very good sonnets in
Provençal and sometimes in
French.*
To Theo, October 1888.

A blue cart at Arles, a souvenir of Vincent.

only the courtyard. Outside the town, he painted the Alyscamps, the necropolis that has now become a promenade. It was here that he competed with Gauguin when the latter came to join him, but where he accorded no particular attention either to the porch of the Saint-Césaire-le-Vieux church, or to the Chapelle Saint-Accurse, or to the Saint-Honorat Church, which receives a pretty light from openings in the arched roof.

Vincent loved nature and trees. As a good disciple of the painters of the Barbizon school and the Impressionists, he loved to paint from life; to spend the day in the countryside, even if it meant that he had to weigh down his easel to help it resist the mistral wind. He feared the remarks of curious passersby, when they saw what might be perceived as barbaric painting to those who were not familiar with the theories of this modern art. Vincent loved solitude and the countryside. To begin with, when he was living in a hotel, he only had his room to paint in. Then when he had set up his studio in the Yellow House, he went about the

The Alyscamps.
These tree trunks are lined like pillars along an avenue where there are rows right and left of old Roman tombs of a lilac blue. And the soil is covered with a thick carpet of yellow and orange fallen leaves.
To Theo, November 1888.

countryside a little less. He stayed indoors mostly when the weather was bad, or to develop his "studies" into finished paintings. His main ambition, of course, was to paint major works that would achieve recognition as modern art by going further than the quick sketches from nature in the Impressionist manner—"wanted" paintings as he called them in his letters. But he still felt too young, too inexperienced, after only a few years of painting, to be really competent. So he worked, training his eye and his hand—especially his hand—for his eye saw the paintings even before he started to paint, and replicated them faster than he could paint them. He reveled in the spectacle of this countryside that he explored with joy in its bright light and bold colors, from the first almond blossoms to the wheatfields oppressed by the sun.

When he stepped off the train at Arles station, it was snowing. This was enough of a surprise to the northerner who was arriving for the first time in the South he associated with Cézanne and Monticelli. It was February, of course, but snow is not a common occurrence in Provence! Straight away, he did a study of it, as well as a "view of a bit of pavement with a pork-butcher's shop." The almond blossom was already visible and Vincent, who for some time was a fervent devotee of Japanese art, made it his nectar, in the manner of the Japanese woodcuts, audaciously framing the subject the better to enhance it. It was also for him a way of remaining an Impressionist, working in bright color and the taste of springtime. It may have been an effort to produce a style of painting that would sell. Never having been a city dweller at heart, first of all Vincent turned to landscape to cleanse himself of the Paris he had wanted so much to leave. He had always been a man more at

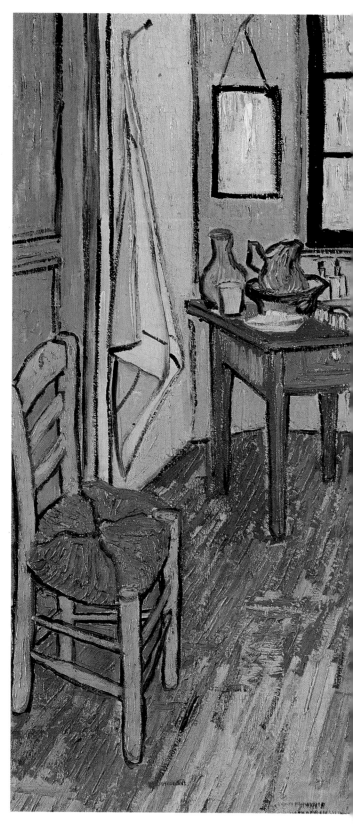

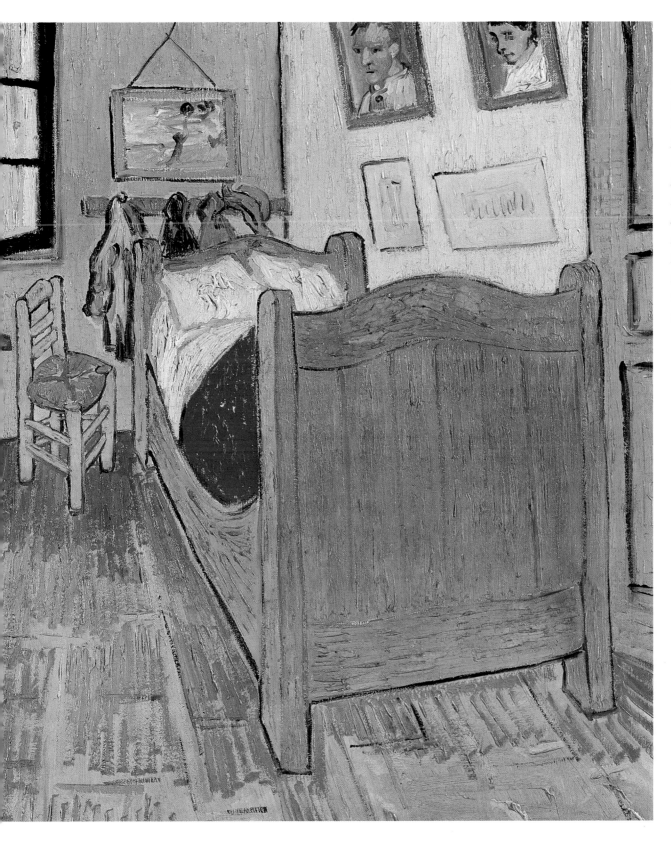

The Artist's Bedroom at Arles,
September 1889.
Musée d'Orsay, Paris.
I live in a little yellow house
with a green door and green
blinds, whitewashed inside. On
the white walls very brightly
colored Japanese prints, red
tiles on the floor. The house is
in full sunlight, and over it an
intensely blue sky.
To his sister, June or July
1888.

home wandering the countryside, setting down his easel there, fascinated by the vast expanse of sky and earth, the innate power of the trees, the generosity of the fields, from Zundert to Auvers-sur-Oise, going through Crau and the countryside of Arles along the way. Arles was where his talent matured fully.

Then there was the season of the orchards—plum trees, apricot and other fruit trees, trees occupying more or less space in the landscape, until this last study done at the end of April, which Vincent described in a letter to Theo: "It's absolutely clear, and done all at once. A frenzy of impastos of the faintest yellow and lilac on the original white mass." A strange contrast with Van Gogh's repeated statements about having to build paintings carefully in their own time, finishing them in a calm and unrushed manner. He in fact showed a rare panache for running off canvases one after the other, and right up to the end of

The plain of the Crau.
I won't hide from you that I don't dislike the country, as I have been brought up there—I am still charmed by the magic of hosts of memories of the past, of a longing for the infinite, of which the sower, the sheaf are the symbols—just as much as before.
To Émile Bernard, June 1888.

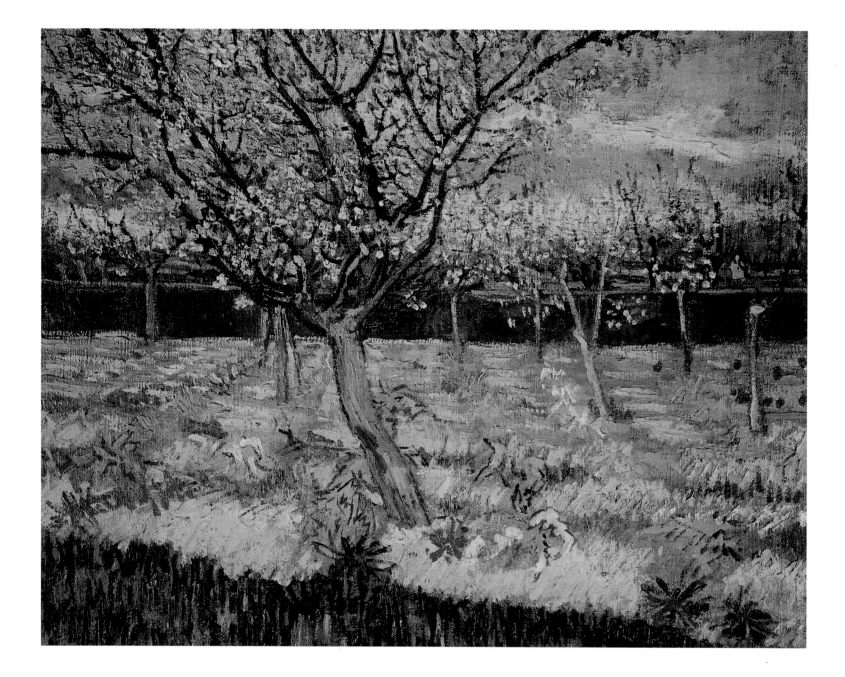

his life in the wheatfields at Auvers, he would be carried away by his brilliant impatience when he really wanted to keep calm and in control. He is continuously shown as impetuous, impassioned, and fanatical about painting, but it should never be forgotten that this strenuous worker studied the forces of nature more carefully than at first sight. This is evidenced in those admirable drawings made with cut reeds, where the sensual force of the line goes hand in hand with figurative precision in the exactness of the composition (but the drawings were sometimes done after the painting).

Few bouquets are seen in Vincent Van Gogh's paintings or few still lifes. Studio painting was not his strong point, although in Paris a worn-out pair of shoes and some withering sunflowers had already demonstrated his admirable skill in this genre. There were, of course, other sunflowers to follow after the incident with the cut ear, and the beautiful irises at Saint-Rémy, but for the main part, Vincent in Provence was an artist who painted out of doors. He preferred to paint flowers in their natural state, irises growing in gardens, or as blossom on the trees or wild in the fields, like the fragile poppies whose unmistakable red highlights a canvas so well.

Vincent was not afraid to cover miles with his artist's equipment on his back. After the orchards, the wheatfields attracted him. He wanted to paint the summer as he had painted the spring. Jean-

OPPOSITE

The Orchard in Bloom. Collection Bührle, Zurich. *I'm up to my ears in work, for the trees are in blossom and I want to paint a Provençal orchard of astounding gaiety.* To Theo, March or April 1888.

BELOW

In the countryside near Saint-Rémy.

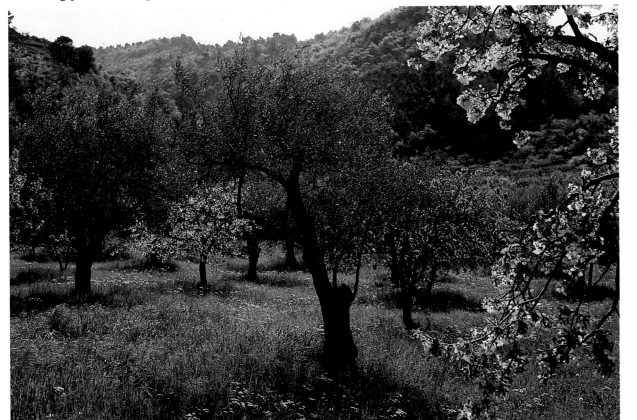

François Millet had captured so beautifully the work in the fields, harvest time, the sowing and the reaping, the working of the land that nourishes man. This was symbolic to Vincent—sowing and cultivating in the hope of a future harvest, in the expectation of the moment when he would really be the artist he knew he was capable of being.

It was a peaceful, harmonious countryside Van Gogh painted in Provence, a countryside from which man was virtually absent, usually scarcely more than a small silhouette, with no dramatic effect, with no weight of human destiny. Vincent Van Gogh, in the summer of 1888, was a happy artist, an artist who portrayed a certain pleasure at being in the world, in harmony with nature. The dramatic tones of the Bible, of which he had been an avid reader, and whose words he had wished to spread zealously, now appeared far away, replaced by the pantheist lyricism of Zola. In fact, he had featured *La Joie de Vivre* beside the Bible in a beautiful still life in 1885, at a time when in the Borinage, he was just becoming a painter. Zola was also a man from the South and a man who believed a little more happiness was possible on earth without waiting for heaven; or who thought that heaven was on earth, at Paradou for example, not far from Arles, where one of his characters, the Abbé Mouret, had felt his flesh coming alive. Zola was also sensitive to the poverty that does not prevent dignity, to injustice that must be combatted, to a brotherhood of ordinary people. Van Gogh read Émile Zola as he read Jules Michelet, in the same way as he regarded the paintings of Jean-François Millet or those of Jules Breton, so many writers and painters who had taken the sense of humanity to its highest degree in their work. Van Gogh was not a socialist like the postman Roulin who had uncompro-

Is it not emotion, the sincerity of one's feeling for nature, that draws us, and if the emotions are sometimes so strong that one works without knowing one works, when sometimes the strokes come with a continuity and a coherence like words in a speech or a letter, then one must always remember that it has not always been so, and that in time to come there will again be hard days, empty of inspiration.
To Theo, June or July 1888.

The Langlois Bridge at Arles,
March 1888.
Rijksmuseum Kröller-
Müller, Otterlo.
As for my work, I brought back
a size 15 canvas today. It is a
drawbridge with a little cart
going over it, outlined against a
blue sky, the river blue as well,
the banks orange-colored with
green grass, and a group of
women washing linen in smocks
and multicolored caps.
To Theo, March 1888.

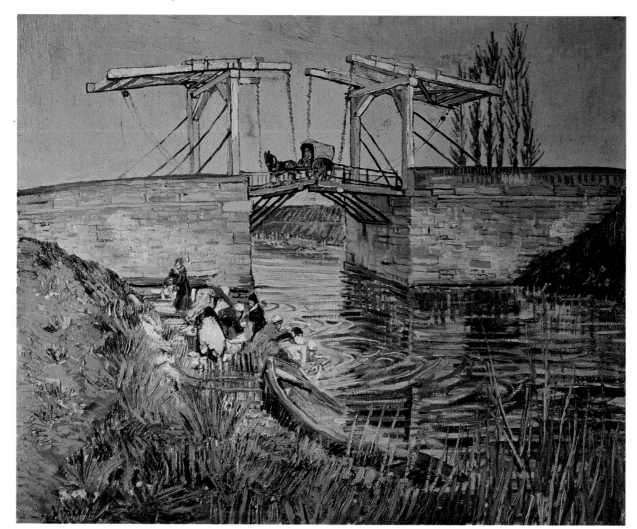

mising revolutionary ideals and had remained faithful to the Paris Commune, which was contemporary to the beginnings of Impressionism. Van Gogh identified with the lowest citizens, from the Dutch peasant made famous by a dish of potatoes, to the very serene portrait of the handsome Patience Escalier, the humble gardener in the Crau. Vincent walked in the countryside around Arles and went into the Crau, where agriculture was still struggling against marshland. He painted gardens, orchards, and fields. He painted the Langlois Bridge, as it was called, after the name of the man who raised and lowered it as required by the boats making their way up and down the canal. It was a double drawbridge installed between Arles and Bouc, to the south of the town, similar to numerous others in the vicinity. No doubt it reminded the artist of the bridges he had seen in Japanese engravings with silhouetted figures topped with parasols. The canals still cross the countryside but they are no longer used by sailboats, so the drawbridges are no longer required.

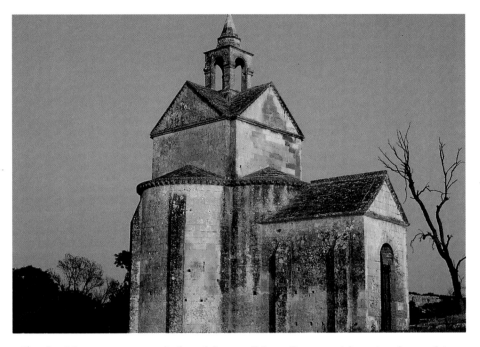

The Abbey at Montmajour.
I have been so afraid of religion
for many years.
To his sister, April 1889.

They had become outmoded and have all but disappeared, but one of these bridges has been conserved, moved, and installed on a part of a canal as if it were the real Langlois Bridge, as Van Gogh painted it in 1888 with the house of the bridge attendant beside it. Vincent visited Montmajour, which is only a few kilometers from Arles, but there again he didn't spend much time looking at old stones. However, the Notre-Dame-La-Blanche Abbey, which has been well restored today, is magnificent in its Benedictine nobility—"a ruined abbey on a hill planted with holly, pine and gray olive trees." In 1316, Abbot Bertrand de Maussang was buried there on a site that was once occupied by an old hermitage. There, in the cloisters, several columns are decorated with sun heads. There, the Pons de l'Orme tower is a turret once used as a look-out for the arrival of brigands. The edifice that dominates the plain is spectacular; it imposes its vertical presence like a prayer, like beauty itself. There is a truly spiritual presence

evident in the architecture that you would think must have appealed to an artist so marked by religion as Vincent Van Gogh. But no, he only painted it from a distance, turning his back on it to contemplate the Crau toward Cordes mountain, toward Barbegal and Fontvieille, where some of his painter friends lived—the American, Dodge MacKnight, and the Belgian, Eugène Boch, who posed for him as a poet on a background of starry sky. Boch's sister was the only person to buy one of Van Gogh's paintings during his lifetime. She bought it when a few of them were exhibited in Belgium. These painter friends sometimes came to see him at the Yellow House and he would visit them in a village which must have also pleased him, as it was marked by the memory of Alphonse Daudet. There is a windmill there which is not really the windmill in the book *Lettres de mon moulin* (*Letters from my Windmill*), but readers of the *Petit Chose* visit it with emotion.

Vincent liked Tartarin, the cowardly, boastful

predator from Tarascon, the region of Tarasque—the wicked monster that came out of the marshes to feast on human flesh before it was conquered by the faith of Saint Marguerite and became as meek as a lamb—was this not the same fabled crocodile that stalked the marshes that used to be the Crau? At that time the journey from Arles to Tarascon was by coach and Vincent painted the stagecoach awaiting departure. He also painted the road to Tarascon.

He wasn't far from the sea, and he did not know the sea very well. He had lived for a short time at The Hague, and on Sundays from there he could easily reach Scheveningen on the North Sea, but that was when he had just started painting, so he only brought back a few paintings from there. He wanted to be a complete artist; he wanted to pit himself against all subjects, all difficulties; he wanted to be infallible, capable of meeting every kind of challenge. Van Gogh wanted to see the sea,

and to paint the sea. He knew that at Saintes-Maries-de-la-Mer, there was a picturesque fishing village and that gypsy celebrations were held there. He spent a week there and, in fact, that was long enough for him to prove to himself and to prove to us even today that he could be an excellent painter of seascapes.

"The Mediterranean has the colours of mackerel, changeable I mean." Van Gogh was not lacking in humor in his discovery of this sea of the South, and no doubt the weather was not fine and

and nine drawings, five of which he sent to Theo straight away. Then, when he got back to Arles, he did a further three paintings inspired by Saintes-Maries, based on his drawings. That was it as far as the sea was concerned. He thought he would return to the sea soon, but he was having the Yellow House repainted and the lack of money prevented him from doing so. One of the boats bore the name *Amitié* (Friendship). It may have been Vincent who gave it this name in his painting *Fishing Boats on the Beach at Saintes-Maries*, which is always reproduced without the anchor which, on the left, constitutes a black sign that holds the

Opposite

On the road to Tarascon.

Left and Below.

Tarascon.

To do good work one must eat well, be well housed, have one's fling from time to time, smoke one's pipe, and drink one's coffee in peace.

To Émile Bernard, September 1888.

settled when he arrived in Saintes-Maries on May 30, 1888. The sea was rough and the sky is not blue in the paintings he did; the boats were sailing with their sails puffed out with wind or lying on the sand, their masts composing an elegant design on a background of whitish clouds. The color changed rapidly, and the part in him that was Impressionist had nothing to complain about, neither had the swift artist in him, who was capable of capturing a subject in a flash. He stayed there less than a week, producing three paintings

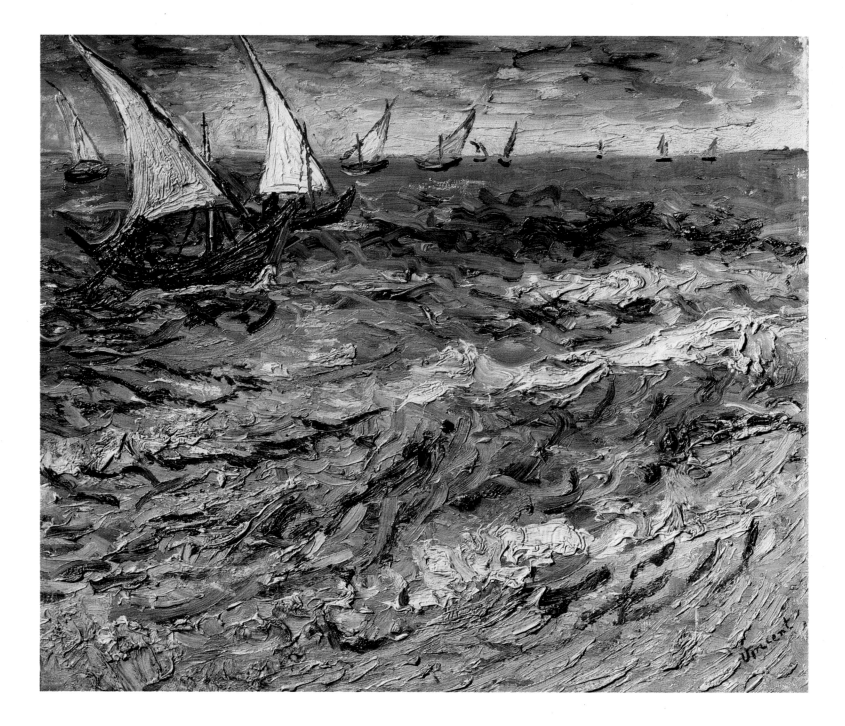

OPPOSITE

Fishing Boats near Saintes-Maries, Arles, June 1888. Pushkin Museum, Moscow. *I am at last writing to you from Saintes-Maries on the shore of the Mediterranean. The Mediterranean has the colors of mackerel, changeable I mean. You don't always know if it's green or violet, you can't even say it's blue, because the next moment the changing light has taken on a tinge of pink or gray.*

To Theo, June 16, 1888.

OPPOSITE PAGE

Hospital porch at Arles.

whole composition together.

Gauguin made it known that he was planning to accept the offer of the Van Gogh brothers, and that he would soon arrive in Arles. Vincent had great hopes of founding their artists' community. This would be the starting point for the Atelier du Midi; other painters such as Émile Bernard would no doubt come later. Provence would trump Brittany and the Paris area. It would be better to go out and paint from nature with this older artist for whom he had great respect, rather than with the sublieutenant of Zouaves Milliet, who painted as an amateur but was unaware of developing trends in modern painting and didn't understand his companion's painting at all. It would also be better than with the painters from Fontvieille, who were good friends, but mediocre artists. Vincent needed to be less alone in this surprising adventure that had carried him into the path of modern art, and here in Arles there was no one with whom he felt able to share any of it. He couldn't talk about it with the good-hearted Roulin, nor with the pastor Salles, to whom Theo had written asking him to keep an eye on his brother. Vincent had accepted an invitation to dine at his house with some reluctance, for his relationship with his paternal religion had deteriorated a great deal. But Salles had gained the confidence of the artist with whom he went walking on the banks of the Rhône.

The liaison with Gauguin only lasted the few

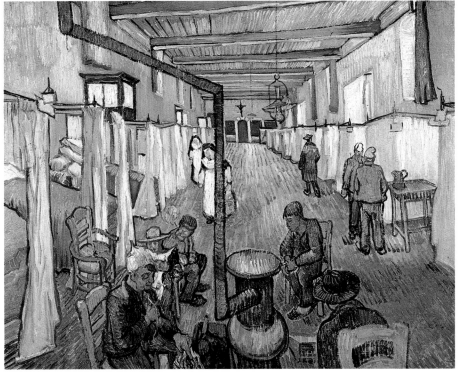

months from October through November. The story has been told many times. The way Gauguin's room was decorated with sunflowers, the housekeeping dependent on the money sent by Theo, pocket money also distributed for tobacco and the brothel. The painting was impassioned, the discussions heated. Gauguin had acquired a reputation as a master in Brittany, and his theory of "synthetism" had been adopted by his followers. Van Gogh's strength was drawn from his unique solitary experience. Vincent's crisis, when it came, was attributed to temporary insanity or perhaps an epileptic seizure. Then came the chase in the street, a lacerated ear, the scandal, hysteria in the brothel, and the subsequent police inquiry. Gauguin, who was suffocating at the Yellow House in a town he did not like, boarded the train for Paris, but not without first warning Theo that he should come

The Hospital at Arles, April 1889. Collection of O. Reinhart, Winterthur.

OPPOSITE
The hospital garden today.
What comforts me a little is that I am beginning to consider madness as a disease like any other and accept the thing as such [...]
To Theo, April 21, 1889.

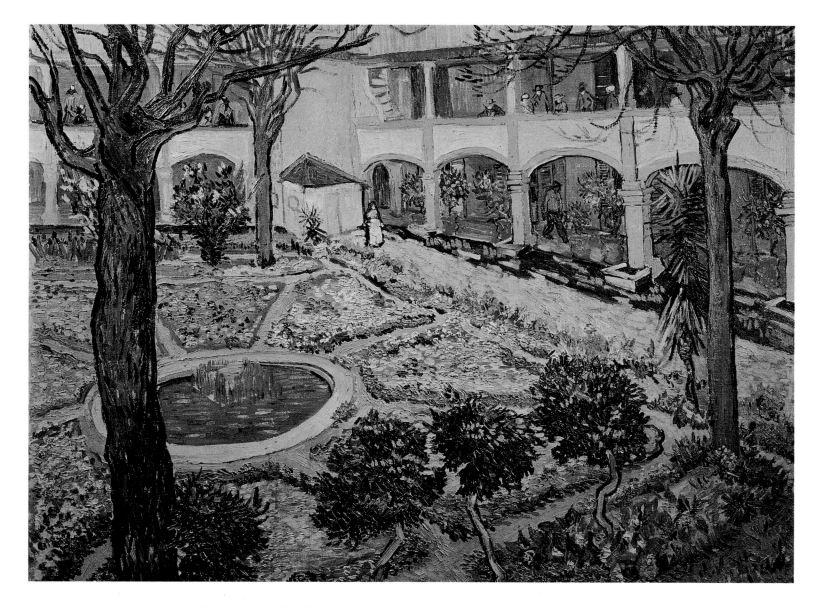

and take care of his brother, who had lost a lot of blood, and had been taken for dead.

It was thus that Vincent Van Gogh came to spend a few days at the Hôtel-Dieu in Arles, where he was fortunate enough to be entrusted to the care of Félix Rey, a young intern who was to become his friend. Rey sat for a portrait, and was still there a month later with Roulin and Ginoux,

when Vincent was again in need of care. It was gradually becoming obvious that he would not be able to live alone in peace of mind and harmony with his neighbors. To the disappointment of the failure of the Atelier du Midi project was added the consequence of too many years of deprivation, bad food, strenuous work, alcohol and tobacco abuse—all of that on top of an already heavy

Nobody knew how to take care of him to avoid another crisis. He couldn't imagine going back to Paris, to be a burden to Theo who had just got married, and where could he live and how? He still wanted to paint the South, Provence, this land of light and color that had put strength back in his palette and control in his draftsmanship. Rey found the solution: the hospice at Saint-Rémy, not too far from Arles and the friends Vincent had there; he would be able to stay there, and he would be cared for, and he would be able to paint at the same time.

Saint-Paul-de-Mausole is still a psychiatric hospital, but the comfort and the care are less minimal than they were at the end of the nineteenth century where, Vincent complained, the patients were kept sedated with drugs, badly fed, left to their own devices and to boredom and, where himself, he said, was really going to go mad. Nonetheless, he stayed there for a whole year, sub-

genetic burden. The Yellow House was closed and the furniture kept by the Ginoux, and for some time Vincent was at home in this hospital which is today called the Espace Van Gogh, a cultural-activity center. He painted the common room with a group of patients sitting around the stove. He also painted the star-shaped garden in bloom, with its central goldfish pond and surrounding double gallery of cloisters.

He had to leave. Vincent could not spend the rest of his life in the hospital at Arles. But where could he go? His health was cause for concern. He could lose his mind from one minute to the next.

OPPOSITE
Garden of the Hospital at Arles,
April 1889.
Collection of O. Reinhart,
Wintherthur.
I am thinking of frankly
accepting my role of madman,
the way Degas acted the part of
a notary. But there it is, I do
not feel that altogether I have
strength enough for such a part.
To Theo, March 24, 1889.

LEFT
The cloister of the hospital
at Saint-Rémy.

BELOW
The Alpilles hills.

The hospital, Saint-Paul-de-Mausole at Saint-Rémy-de-Provence, where Vincent was interned.

ject to several terrible psychotic episodes. He tried more than once, it seems, to poison himself by eating paint, but he did paint in the asylum itself and when he was relatively well, in the countryside around it. Fascinated by the Alpilles hills, the quarries at Saint-Rémy, the olive trees and the cypresses, he progressed through yet another stage on his path as a brilliant artist. There were more wheatfields, harvests, a reaper among the golden ears, a golden yellow that united the wheat and the sun, and which was painted by the artist who sought what he described as the "high yel-

them, but at Saint-Rémy he could not escape the omnipresence of this tree of the South that is a blot on the landscape and that he found terribly difficult to paint. He was sometimes able to produce lively images thanks to his flamboyant brushstroke that worked very well with green in all its nuances and resulted in impastos reminiscent of the great Monticelli from Marseilles he loved so much. That was really, for him, what painting Provence was all about. It also provided a companion piece to the sunflowers. "When I had done these sunflowers," he wrote to Theo, "I looked for contrast and its equivalent, and I said: it is the cypresses." The olive trees were not any easier to paint than the cypresses, and they had not yet found a great artist to do them justice, while the trees of the North, the

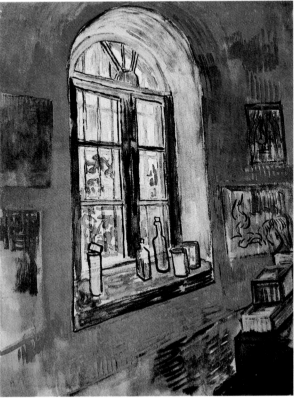

Window in Van Gogh's Studio in the Hospital, May–June 1889. Rijksmuseum Vincent Van Gogh, Amsterdam.
As for me, you know well enough that I should not exactly have chosen madness if I had a choice, but once you have an affliction of that sort, you can't catch it again.
To Theo, April 21, 1889.

low note" to render "the extreme heat." It was also an image of death, he confessed to his brother, but a death that was not sinister. No more sinister than the cypresses, so often associated with graves as at the end of the lane of Alyscamps, for example. In the great necropolis of Arles he paid no heed to

willows and poplars, had reigned supreme in painting for a long time. Perhaps he was the artist who would give the trees of the South their real place in painting. Then there were the pines in the garden of the asylum, and the plunging views behind it of the quarries, and beside them the ruins of the ancient Roman town of Glanum for which they yielded the stone. The third *Starry Night*, set this time in the countryside above a calm village, is a sumptuous creation, with cypresses in the fore-ground and in the sky a thick crescent moon accompanied by huge swirling stars in the same intense yellow he used to paint the wheat and the sun. The stars are formed with a heavy central application of paint surrounded by a solid-looking halo. This strange cluster is transfixed in its move-ment across a turbulent sky. When he could not leave his room, he paid homage in his own way to Jean-François Millet and transposed a series of engravings, illustrating workers in the fields, into

Starry Night over the Rhône at Arles, September 1888. Musée d'Orsay, Paris. *A starry sky, for instance — look, that is something I should like to try to do, just as in the daytime I am going to try to paint a green meadow spangled with dandelions.* To Émile Bernard, April 1888.

<small>OPPOSITE</small>
The Alpilles hills.

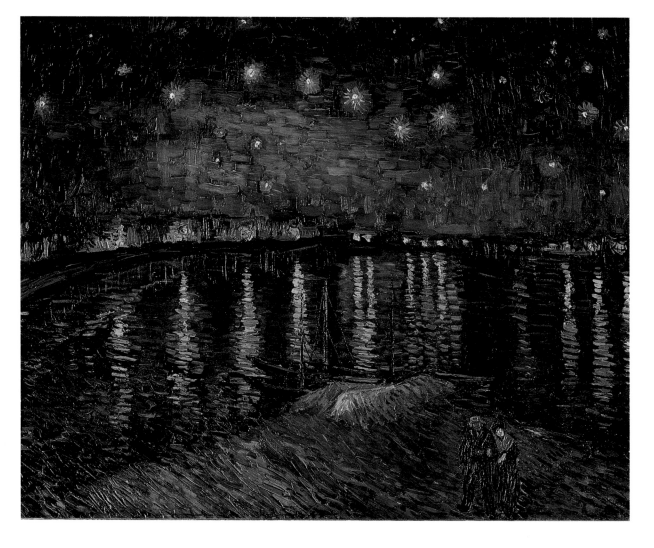

paintings with the warm lyricism and great finesse of a painter. There were also a few portraits which, after those of Arles, confirmed his strength and originality in this genre, which he regretted not taking more time to practice. Trabuc, the charge nurse in the asylum, he drew with great sensitivity in a bluish soberness. A patient, a peasant, and a few self-portraits bear witness to the same graphic precision, but there is less emphasis on color than in the portraits in Arles or in the famous *Self-Portrait with Bandaged Ear*. Finally, there was one of the most astonishing and purest paintings he ever accomplished, the marvelous *Irises*, "against a bright lemon-yellow background, with other shades of yellow in the vase and the base it is sitting on, with an effect of the most terribly incongruous complementary colors that exalt each other in their opposition," as he wrote.

Any artist capable of such painting could not be all that mad. In fact, when he was not actually in the throes of an attack, he was not mad at all. He was perfectly capable of a formidable lucidity, all in harmony with nature and happy to be painting, to be painting balanced painting, expertly composed and colored, intense, more "wanted" than in Arles, strangely turbulent but never out of control. "Fundamentally I am not so violent as all that, and at last I myself feel calmer," he wrote in December 1889 to Theo. Shortly afterward he suffered an attack that proved to be much more serious than his previous ones. The effects lasted for two months and distressed him enough to make him want to leave the South and return to the countryside of the North to Auvers-sur-Oise, where Dr. Gachet said he would look after him. He decided to go to Paris again to see Theo, his young wife Jo, and the baby Vincent. He could visit his painter

friends and the museums and galleries and work again in the soft Paris light. He wrote to his brother on May 14, 1890, the last letter sent from Saint-Rémy: "I tell you, I feel my head is absolutely calm for my work, and the brushstrokes come to me and follow each other logically."

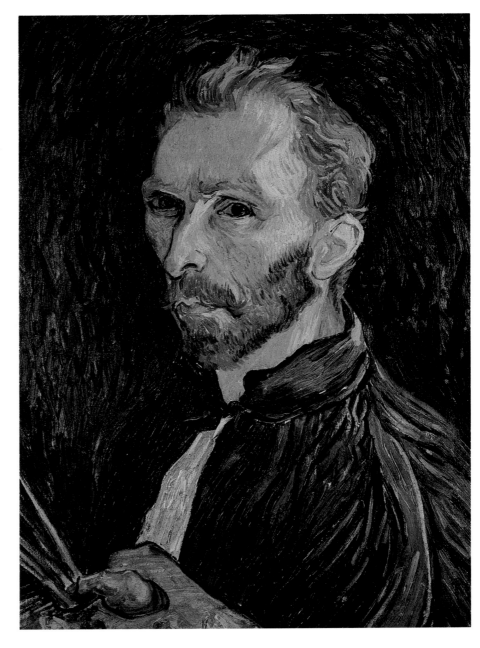

OPPOSITE

The air here certainly does me good. I wish you could fill your lungs with it.
To Theo, April 1888.

OVERLEAF

The Alpilles hills.

Self-Portrait, Saint-Rémy, Finished August 1889. J.H. Whitney, New York. *The more ugly, old, vicious, ill, poor I get, the more I want to take my revenge by producing brilliant color, well-arranged, resplendent.*
To his sister, September 1888.

And mind, my dear fellow,
Paris is Paris. There is but one
Paris and however hard living
may be here, and if it became
worse and harder even — the
French air clears up the brain
and does good — all the good in
the world.
To H. M. Levens, 1886.

Paris, the Time of the Impressionists

Paris at that time was the capital of modern art; Impressionism was in triumph in the city. Vincent Van Gogh came to Paris for the first time, briefly, in 1873, on his way to London. He went to the head office of the company of art merchants Goupil & Cie (that later became Boussod & Valadon). He had been employed in their office in The Hague as a dealer in engravings, before he was sent to England, and promoted to the position of dealer in paintings. Three years after the Paris Commune, he saw the Louvre and the damage which the fire had wreaked on the Tuileries Gardens; the ruins of the Vendôme Column that had been destroyed, at the instigation of the painter Gustave Courbet, it was erroneously reported. He went to see the Luxembourg Palace where the most recent paintings from the National Collections were exhibited. That particular year, the Salon, which was being held at the Palais des Champs-Élysées, awarded its Medal of Honor to Jules Breton, a painter who is almost unknown today, but for whom Vincent always held a great admiration.

One year later, Vincent returned for a longer stay in Paris, having been appointed to work at the Goupil gallery in the Place de l'Opéra. He had been a disappointment to his employers in his previous position, as he had not turned out to be a convincing art dealer and had even then begun to show worrying personality traits. His strong tendency to bouts of depression had destroyed his employer's confidence in his ability to undertake a serious career in art dealership. To be honest, if it hadn't been for the fact that he was the nephew of Vincent Van Gogh, the Dutch partner Goupil referred to as Cent and a much more successful man than his clergyman brother, the owner

Self-Portrait in Front of the Easel, Paris, early 1888. Rijksmuseum Vincent Van Gogh, Amsterdam. *In every man who is healthy and natural there is a germinating force as in a grain of wheat. And so natural life is germination. What the germinating force is in the grain of wheat, love is in us.* To his sister, 1887.

I have taken a little room in Montmartre that I am sure you would like; it is small, but it overlooks a little garden full of ivy and wild vines.
To Theo, July 6, 1875.

of a private mansion in Neuilly, and a man of some considerable influence, Vincent would no doubt have been dismissed. Although he was considered totally unsuited to selling, he had acquired a thorough knowledge of art and practiced his profession with a passion. However, he was only twenty years old and did not have a fully developed personality, had not found exactly what he wanted to do or how he wanted to do it. He was in love but unhappy. Ursula, the daughter of his London landlady, had been indifferent to his advances, so he became more and more persistent in the hope that she would change her mind. He was alternately inflamed with hope and desperation. He began to stay away from the gallery and to neglect

his work. When he went home on holiday, his family found him depressive, which was the word they used at the time (it was, in fact, an illness that ran in Van Gogh's family). Today, we would say he was having a nervous breakdown. In any case, this episode of unrequited love upset him so much he completely changed direction, and revealed another Vincent Van Gogh, suddenly obsessed by the plight of the common people and more passionate about the Bible than about writings on art. "I hope and trust that I am not what many people think I am just now," he wrote from London, on May 8, 1875, to Theo, before he left England, and he added a long quotation from Ernest Renan: "To act well in the world one must sacrifice all personal

desires. The people who become the missionary of a religious thought have no other fatherland than this thought. Man is not on this earth solely to be happy, and not even to be simply honest. He is here to realize great things for humanity, to attain nobility, and to surmount the vulgarity of nearly every individual."

There had been nothing in Vincent's previous behavior, however, to suggest that he was about to put such a regime into practice for the rest of his life. This was, in fact, the state of mind he was in when he arrived in Paris to take up a job his heart was no longer in, and which no doubt his employers had lost faith in his ability to perform. It was only a temporary respite lasting less than a year, a short interval but a crucial one, for it constituted one of the major turning points in his life, and confirmed what was yet to become obvious: the London crisis had been a rebirth.

Paris was also undergoing change. The aftermath of the Paris Commune was a time when the city was being reborn and was crowning the architectural career of Haussmann by building a white basilica on the heights of Montmartre. to seek forgiveness for an insurrection that had been clearly anticlerical. The bourgeois, industrious Republic was emerging like the phoenix out of the ashes of the Second Empire by embracing democracy. An event had taken place the previous year, an event that did not receive the publicity it deserved, but had come to public attention because of a small scandal that had shaken the "good taste" of a public in love with pompous, historical, and mythological nudes: the Impressionists had organized their first exhibition in the studio of the photographer Nadar in Boulevard des Capucines. The new modern art exalted painting that was light and happy, based on respect for nature and a sense of the pres-

ent moment, the daily life of the city and the sub-urbs, which went against all the rules of content and form strenuously preached by the Académie des Beaux-Arts and by "the Salon," the major annual exhibition that was entirely under the influence of the Académie.

It was not long before Vincent returned to the Louvre and to the Luxembourg Palace to acclaim Ruysdael in the former and Jules Breton in the latter and, since it was time for the Salon, he did not miss it. He saw three "very beautiful" paintings by Corot. The painter had recently died, and there was an exhibition in his honor, in which Van Gogh saw and admired *Christ in the Garden of Olives*. The religious theme perhaps had something to do with this enthusiasm because of Vincent's personal concerns at the time, but what he loved most of all in Corot was his feeling for nature, as he did in the painters of the Barbizon group. A month later, when he entered the room at the Hôtel Drouot, the public auction house where Millet's drawings were displayed on sale, he felt that he should take off his shoes, "for the ground you are walking on is sacred." From then on, painting and religion were part of the same cause—painting as a means of paying homage to the nature God created and man who is made in God's image. Painting as prayer, as a path to God, perhaps. In any case, in every letter he wrote to his brother during this stay, from the first to the last, Vincent never failed to mention the pilgrims of Emmaus, those disciples who met Jesus along the way and were the subjects of a superb engraving by Rembrandt.

He rented a small room in Montmartre with a view of "a small garden full of ivy and Virginia creeper." He covered the walls with engravings and listed them for Theo. There were, among others, Ruysdael, Rembrandt, Corot, Millet, a por-

The Farm of Père Éloi,
The Louvre, Drawings
Collection, Paris.
What is to be gained is
progress, and whatever the deuce
that is, it is to be found here.
To H. M. Levens, 1886.

trait by Philippe de Champaigne, Daubigny, and Van der Maaten with *L'Enterrement dans les Blés,* an engraving that had hung in the study of pastor Theodorus Van Gogh. On Sundays, Vincent himself went to one church or another and advised his brother not to miss the Sunday sermon. He would also go to the country occasionally, to Ville-d'Avray, for example, where he found three of Corot's paintings in the church.

The Bible was gradually becoming an obsession. That was the opinion of Uncle Cent, who was keeping an eye on his nephew and trying to defend him to Goupil to keep him in employment, but even he couldn't help Vincent against his will. Theodorus was of the same opinion. Although he was a pastor, he was worldly wise and was suspicious of the over-excitement that accompanies elation. Vincent sealed his own fate at Christmas. He took unauthorized leave to visit his parents in Etten, where the pastor had just been appointed. This was a serious breach of his contract. When he returned to Paris, guilty but unrepentant, he offered no apology for his behavior, and when his employer chastised him for this, he responded by

handing in his resignation. After seven years in the service of Goupil, he walked out of the firm that also employed his brother in The Hague. There had been nothing up till then to suggest that he would take such a drastic course of action, leaving himself virtually without means of support. He was granted a special dispensation to work a three-months' notice.

Vincent was still nostalgic for London, and he often had the opportunity to talk about the city with one of his colleagues, the young Harry Gladwell, who had come to Goupil to learn the profession he was later to practice in his father's firm in London. Harry shared Vincent's room in Montmartre for a short time. Vincent moved back to stay with his parents but they were none too happy about the situation. Van Gogh was starting a new life, a life that did not involve standing in a gallery selling bad paintings to the bourgeoisie; instead, a life in which he could give his best, according to the teachings of a religion that he wished unreservedly to put into practice. For several months he had been poring over *The Imitation of Christ*, the book by Thomas à Kempis, which was then in vogue, advocating the naïve happiness that develops from a life of strict austerity and evangelical charity (he was no less delighted to discover the novels of Erckmann-Chatrian). He bought English newspapers and studied the classified advertisements. Sometimes there were positions advertised for teachers. He offered his services to no avail, until finally, two days before he was due to leave Goupil, he received a letter telling him that he was expected at Ramsgate. He was to be given board and lodging, but no remuneration.

And so Vincent's stay in Paris came to an end, a stay during which he had decisively turned his back on the normal life he could have had. He only

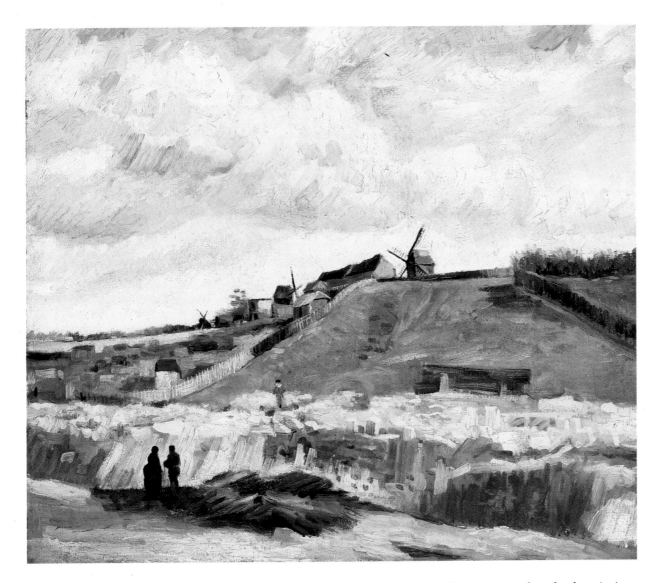

returned to Paris ten years later, after preaching in England and Belgium and failing to become a pastor or evangelist, and only after having committed himself to painting with all the fervor he had previously invested in religion.

He was in Paris again on February 28, 1886, from Antwerp this time where he had frequented the Academy and where he had been impressed by Japanese art. He left again on February 21, 1888, having completed over two hundred paintings there. He was now the great painter that he had not quite been when he left Belgium, before his journey through Impressionism.

He turned up unexpectedly, only announcing his arrival to his brother once he had stepped off the train. He arranged to meet him in the Louvre immediately, in the Salle Carrée where *The Marriage at Cana* by Veronese was exhibited. It

Vegetable Gardens in Montmartre,
Paris, October 1886.
Rijksmuseum Vincent Van Gogh, Amsterdam.

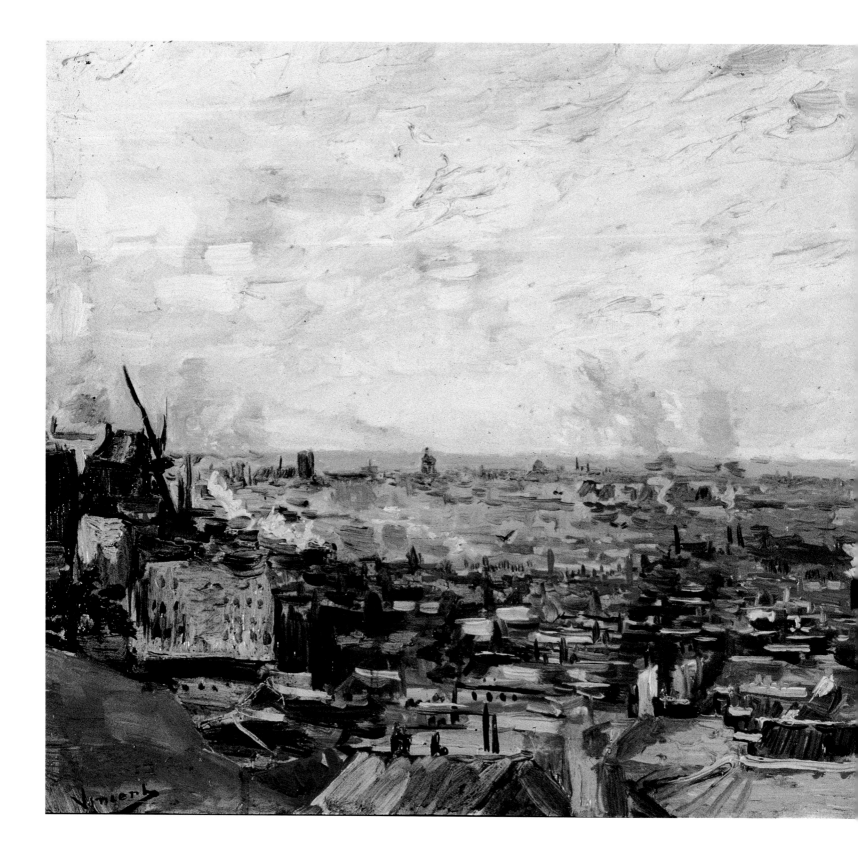

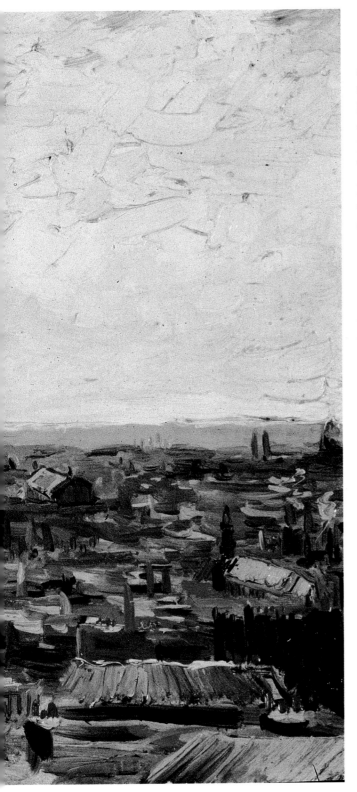

appeared as if he had nothing more urgent to do than visit the Louvre! Theo, on the other hand, had become a Parisian: he was still working for Goupil, and was in charge of the gallery at 19, Boulevard Montmartre, which specialized in "modern" painting, and where he was trying to promote Impressionism. Vincent also found himself living around the hill of Montmartre again, since Theo's apartment was at 25, Rue de Laval (today called Rue Victor-Massé), not far from Place Pigalle and conveniently close to the shop of Père Tanguy (whose first name was Julien), who sold paints and who was a passionate advocate of the Impressionist painters, especially Cézanne. He was always willing to exhibit paintings, and occasionally even sold a few. This was the Nouvelle Athènes quarter, named after the famous establishment on Place Pigalle, just below the Boulevard de Rochechouart, which was formerly the northern boundary of the capital and above

View of Paris from
Montmartre.
Paris, 1886.
Museum of Fine Arts, Basle.
It seems to me almost
impossible to work in Paris
unless one has some place of
retreat where one can recuperate
and get one's tranquility and
poise back. Without that, one
would get hopelessly stultified.
To Theo, February 21,
1888.

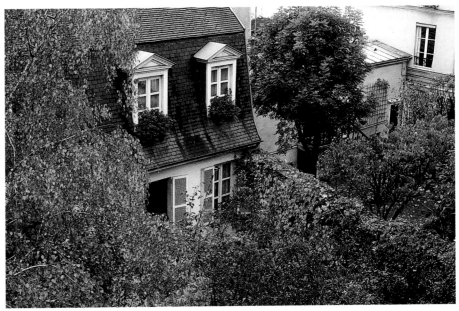

which sits the Butte Montmartre. Montmartre has now become integrated into the city, like certain other places around the periphery, but at that time it was almost in the countryside. Urbanism was encroaching on the hill to which the Sacré-Cœur Basilica gave new pride, but it still had the quality of a popular quarter frequented by the art students whose haunts were the cabarets and open-air cafés, where the bourgeoisie sometimes came to mix with the riff-raff. Nonetheless, in that first year, with the exception of a few views of Paris, including one of the Louvre and another one of the Luxembourg gardens, Vincent mainly devoted

himself to still life in order to improve his painting technique and practice his inherent sense of color that had never been fully satisfied with the chiaroscuro that reigned in Flemish painting. He had also recently discovered the work of Adolphe Monticelli, who executed brightly colored bouquets using thick daubs of paint. Monticelli had left Paris for Marseilles after the Commune and his works could still be seen at the gallery of Joseph Delarebeyrette on Rue de Provence, which was located between the gallery where Theo employed his talents as an art dealer and the apartment where they lived. Vincent felt that he still had a lot to learn, and since his stay in Antwerp he had been hoping to perfect his apprenticeship at the studio run by Cormon, which was situated at the foot of the hill at 104, Boulevard de Clichy, right next to Place Blanche,

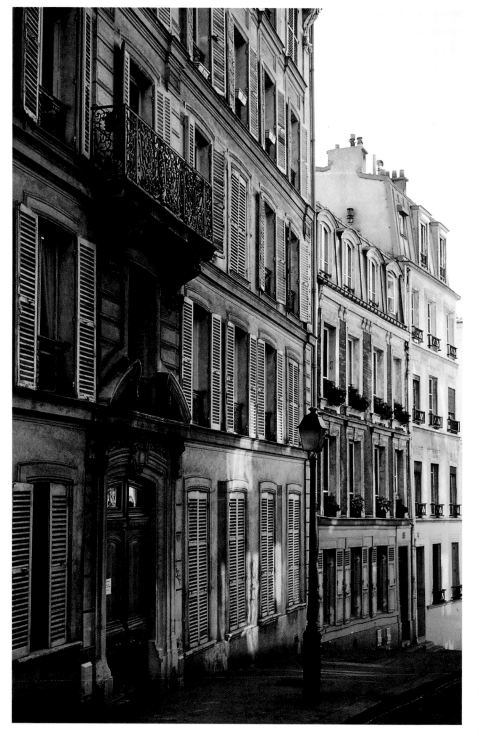

where stands today the famous Moulin-Rouge. Now it has little if anything in common with the original Moulin, but it remains for tourists as a souvenir of what the hill was like when windmills sprouted there, ideally situated to take full advantage of the wind. At that time there were three windmills still in operation, including the Blute-Fin, which boasted an exceptional view. Vincent naturally seized the opportunity to paint it.

Going up the Rue Lepic, part of the urban planning implemented by Haussmann, in a straight line from Place Blanche, where on market days Paris still has a village atmosphere about it, the Rue des Abbesses appears on the left. The climb continues around a bend, up a steeper slope and, on the right, at number 54, there is an inconspicuous plaque on the building stating that Vincent Van Gogh lived and worked here. Theo had found this two-room apartment in June. It was bigger than the one in Rue de Laval, and from his window, Vincent could gaze at the rooftops of Paris under the sky of Ile-de-France that stood out brighter above the capital then than it does today. In fact, it was northward that he preferred to gaze, toward the countryside and the Parisian suburbs of Clichy and Asnières. It was as if he was already preparing to leave the town.

OPPOSITE

The house where Vincent and Theo lived.

LEFT

View of Paris from Vincent's Room in the Rue Lepic, Paris, Spring 1887. Rijksmuseum Vincent Van Gogh, Amsterdam.

My present address is
Mr. Vincent Van Gogh
54 Rue Lepic, Paris.
To H. M. Levens, 1886.

100

Portrait of Père Tanguy, Paris,
1887–1888.
Rodin Museum, Paris.
*So I gave it to that wife of
Tanguy's, and said it was her
fault if I did not buy anything
more from them. Old Tanguy is
sensible enough to hold his
tongue, and all the same he will
do whatever I want of him.*
To Theo, summer 1887.

OPPOSITE

The last windmill in
Montmartre.

Several months passed before Vincent pushed open the door of the studio run by Cormon. Through that door he entered the world of Impressionism, even though the teaching was still, at that time, academic, delivered by an obtuse artist with outdated ideas for whom the ultimate exercise was the copying of plaster models. Cormon was nonetheless a good colorist, and it was this that had made his reputation, even as far as Belgium where Vincent first heard about him from contemporaries at the Academy of Antwerp. Thanks to Theo, Van Gogh had already had the chance to view many paintings from the new school and to meet Lucien Pissarro, the son of the great Camille Pissarro, Henri de Toulouse-Lautrec, the debauched dwarf aristocrat, and Émile Bernard, a man exceptionally gifted in art and literature, and who was to become the main disciple of Gauguin and the theorist of "synthetism." One day, on his way back from a painting session, Vincent met the two Pissarros, father and son, in Rue Lepic near Montmartre. He was excited to meet one of the instigators of the great movement about light in painting—Impressionism—and in his eagerness to show him his latest work he spread the studies out on the pavement.

Today, that part of Rue Lepic that leads up to the hill of Montmartre is rather quiet on the less-frequented side. Undoubtedly, it still holds the memory of the strange painter who often wore a blue peasant's smock, splashed with paint, and who passed by with a somber air, lost in his distant thoughts, or passionately arguing with some companion, recounting his version of the history of art, praising Millet, Corot, and Jules Breton, when the avant-garde no longer had eyes or brushes for anything but Impressionism (which was given an

Painting by André Gill on the front of the cabaret Le Lapin Agile.

Opposite

Garden in Montmartre.
So I, for instance, who can count so many years in my life during which a desire to laugh was grievously wanting [...] I, for instance, feel first of all the need of a thoroughly good laugh.
To his sister, 1887.

unexpected extension by Georges Seurat, who, with his myriad tiny dots of paint was closer to the highly stylized paintings of Puvis de Chavannes than to the feeling for the ephemeral that was one of the golden rules of Impressionism). Vincent had not thought to question the somber style of his Holland paintings; *The Potato Eaters* was acceptable at that stage in his painting career, but the work of Delacroix prompted him to analyze the interaction of complementary colors, taking him further toward expressive color. Irrespective of his periodic affirmation that he belonged to the school of Impressionism, he was never more than a temporary Impressionist, only half-convinced, certain that this was only a stage in his apprenticeship.

This is how he should be seen, practicing the application of small touches of pure color that, seen from a short distance, blend into each other to reinvent the play of light and shade, according to a law of optics described by the physicist Eugène Chevreul. This is how he should be seen on the Butte Montmartre, where he set up his easel to paint the windmills or the view over Paris on one side, the suburbs on the other. This is how he should be followed in his suburban ventures, when he went down to Clichy, Saint-Ouen, and Asnières, succumbing to the attraction of the water, down to the banks of the Seine, with Paul Signac, Émile Bernard, and Armand Guillaumin.

Seurat had just painted his masterpiece,

Dimanche sur la Grande Jatte. He had exhibited at the Salon des Indépendants in the autumn of 1886 this manifesto of a new movement in painting—pointillism, which tended to make of Impressionism a new classical art full of balance and the eternal. Émile Bernard had been so impressed that he had reworked his most recent paintings using these small dots of color. When Vincent saw these paintings in Père Tanguy's shop, he felt a new bond with the painter he had first met at Cormon's studio. It was also in Tanguy's shop that Van Gogh met Paul Signac for the first time. Signac was already having a field day with Seurat's pointillism. Signac also used to go down to the Seine, not far from la Grande Jatte, toward Clichy and Asnières. He did not mind the Dutchman's ostentatious manner and noisy company, and allowed Vincent to accompany him. In this way, Vincent acquired first-hand experience of Impressionism at a time when he was in the process of finding an efficient method for making color sing in a vivid light that totally excluded black. They painted together on the embankments and bridges and lunched in small restaurants which, like everything else, were immortalized on canvas. This was a chance for Vincent to learn about calm in painting, the serene landscape. With the astonishing dedication that never left him, and the fervent willpower of a self-taught painter who did not find his vocation until relatively late in life, he produced some admirable paintings that reaffirm his place as a good second-generation Impressionist. He had wanted to master luminescence in painting and he proved to himself he could succeed as well as anyone else, but there was no question of him simply joining the Impressionist movement. Such pretty painting would not allow him to give full vent to his power-

The restaurant
À La Pomponnette
42, Rue Lepic.
It's better to have a jolly life
than to commit suicide.
To Theo, summer 1887.

ful temperament that protested and urged him to different methods of expression. On the way back home, according to Signac, "he shouted, waved his arms, waving his big size-30 canvas freshly painted and splattered all the passers-by with color."

Absinthe must have played a part in the changes in Vincent Van Gogh's personality. Of course, after the difficult years he had been through in order to become a painter, experiencing extreme poverty, his health had already deteriorated, exacerbating his nervous condition. All the more so because he was highly excited by the course mod-

ern art was taking and by his determination to play a leading role in it. But absinthe was a poison which, although very much in fashion, was nonetheless destructive. Toulouse-Lautrec was much drawn to the drink, and was probably addicted to it; Vincent quickly fell into the habit of joining him in the cult of the green liquor. They drank beer at the Mirliton, where Aristide Bruant sang of the glory of the populace that had perpetrated the Commune, then they made a circuit of the cafés on Montmartre hill, progressing to much stronger alcohol. When necessary, Toulouse-Lautrec opened the cork on the end of his cane that held a secret ration of the green liquid. This joyous nightbird, whose lack of physical grace had not rendered him melancholic, and who belied his aristocratic origins by befriending the vulgar girls from the brothels, gave Vincent much more than a taste for a strong, dangerous drink. He showed him another method of painting, set apart from the main avenue of Impressionism, using the line in preference to the small brushstroke or dot, and choosing social portrait over pastoral landscape. Lautrec was a brilliant poster artist, and had an instinct for composition that was closer to the flat plane and skillful cut-outs of Japanese prints than to classical perspective.

Vincent painted the café with the glass of absinthe on the table and during this phase he also observed the strange characters caught up in the mesh of alcoholism, left in the wake of economic progress and social success that was sweeping the triumphant bourgeoisie toward the end of the century. Vincent had taken advantage of the models posing at Cormon's studio to work on nudes, but he soon tired of the rigid academic atmosphere and only stayed there for three or four months in the spring of 1896, as he wrote to his sister Willelmien.

Vincent was more interested in portraits than in still life or landscape, for that was what he wanted to paint. He was determined to paint portraits but he would have to find models, and he would have to pay them. This would prove to be difficult because he didn't exactly make life easy for models with his sudden fits of rage. The balance of his mind was affected by excessive absinthe drinking and was becoming a cause for concern. Even Theo complained that it had become increasingly difficult for them to live together,

and Theo's love for his brother and the loyalty he tried to show him, even when he found it hard to follow his artistic endeavors, were sorely strained. They both confided in their sister who was not entirely free from mental problems herself. She lived longer than either Vincent or Theo certainly, but spent the last period of her life in a psychiatric hospital. Theo confessed that life was becoming almost unbearable; nobody was coming to the apartment anymore, for Vincent was always picking fights. He went on

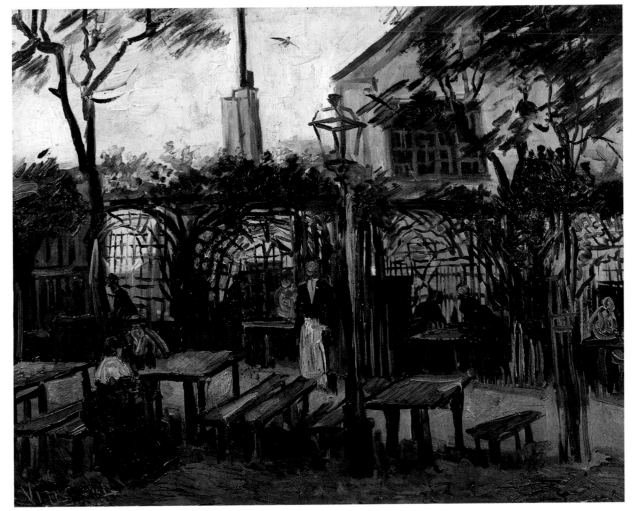

The Small Tavern at Montmartre, Paris, October 1886.
Musée d'Orsay, Paris.
However, I have faith in color. Even in regard to the price, I believe that in the long run the public will pay for works high in color.
To H. M. Levens, 1886.

A Pair of Shoes,
Paris, 1886.
Rijksmuseum Vincent Van
Gogh, Amsterdam.
The diseases that we civilized
people labor under most are
melancholy and pessimism.
To his sister, 1887.

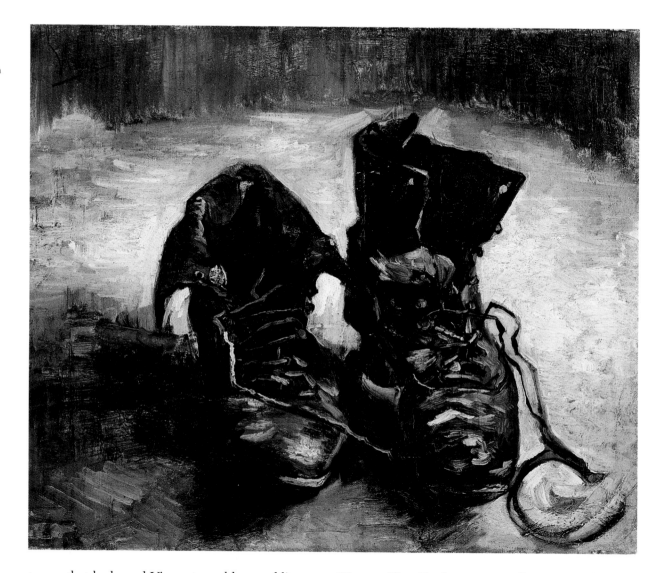

to say that he hoped Vincent would go and live on his own somewhere. He had already mentioned this, but he knew that if he were to suggest it, it would make Vincent all the more determined to stay. Theo felt guilty about wanting his brother to leave, and in the same letter expressed the fact that he did not wish his brother any harm, but that he did not wish to be harmed by him either. So everything was not completely rosy in the kingdom of Paris where the Dutchman Vincent Van Gogh was struggling against himself and against painting.

It is curious that although Vincent was always searching for models, he never painted his brother. There is not a single painting of Theo in Vincent's portrait gallery. The reason for such an omission gives rise to endless speculation. Certain analysts have tried to interpret the famous pair of shoes as a representation of the two brothers forming a pair, but such symbolism, while amusing, is hardly

relevant. It does not, in any case, teach us much about one or the other. There are only photographs of Theo, so it seems that none of the other painters he encouraged and even assisted were inclined to paint his portrait.

Vincent, on the other hand, was the subject of a sketch by Lucien Pissarro, alongside the art critic Félix Fénéon, his arms firmly crossed like someone who is prepared for adversity of some sort. His eyes are narrowed in a frown, his face tense, his mouth slightly open, but with taut lips. He also appears in the pastels of Toulouse-Lautrec, in profile, leaning on his elbows, bending slightly forward over a table on which there is a glass. He is apparently concentrating with a look of seriousness and determination either on an idea or on what is in his line of sight, but which we can't see. He was also painted by his friend, John Russell, in the formal manner of Flemish painting, in a three-quarters portrait on a black background. During his stay in Paris he is most often seen painted by his own hand in a stunning series of self-portraits that plots the entire progression of his painting from somber chiaroscuro to impressionist radiance, with mounting emphasis on color, using staccato brushstrokes or dots and inventing his own method of firm lines. The eyes are always wide open and fixed on some target; the expression is never peaceful, but always fundamentally grave, giving a rather romantic image of the artist that provided solid support for the legend of the tortured artistic temperament. There is more character, more originality, more genius in the self-portraits than in the still lifes and landscapes of the same period. There is even a kind of split between, on the one hand, the peaceful, dutiful painting of the student of Impressionism, and on the other hand the aggressive determination of a painter

guided only by the voices in his head. This is also mentioned in the letter Theo wrote to his sister, where he said it was as if Vincent was two people—one, wonderfully gifted, charming, and sweet and the other totally self-centered and ruthless. Where the younger brother was wrong, was that it was the "other" who was more talented than the first, and that it was the latter who would be given an exceptional place in the history of painting. It was the second one who gave strength to the first, already in the confusion of those Parisian years, and helped him to preserve his confidence in his endless struggle to master the art of painting. But Theo was wrong when he went on to say that Vincent was his own worst enemy. Although it was true that the painter was ruining his health and disturbing his mind, it was no doubt due less to alcohol abuse than to the sheer violence of the experience he was going through, constantly

I set off again. It was fine to walk at that time.
To Theo, June 17, 1876.

*Street with Woman Walking
her Dog*, 1886.
Rijksmuseum Vincent
Van Gogh, Amsterdam.
*As for me, I feel I am losing the
desire for marriage and
children, and now and then it
saddens me that I should be
feeling like that at thirty-five,
just when it should be the
opposite.*
To Theo, summer 1887.

doubting himself, reinventing painting in order to make it totally his own. If we concede that Vincent was his own worst enemy, it was because he was obliged to live and create like all great artists, fighting against the part of himself that was afraid of adventure, afraid of his own audacity, that could force him to become a bland painter and a "nice" person, just as he had been a timid art dealer. The gentle Vincent and the terrible Vincent were one and the same; it could not have been easy for Vincent himself nor for his brother to witness such

a formidable internal conflict. This gentle, terrible Vincent, selfish and yet remarkably selfless, led his Impressionist friends in the struggle, setting up a controversial exhibition in The Chalet, a café at 43, Avenue de Clichy, which he used to frequent. Émile Bernard and Louis Anquetin, with whom he went down to the banks of the Seine to paint (a photograph shows him, from the back, in conversation with Bernard at the edge of the river), were there, as was the Dutchman Hans Koning. It was not an insignificant event, in the quarter! The elders, Pissarro and Guillaumin, came to see the work of these young painters who followed them out of respect but without submission, and Gauguin who, from Pont-Aven to Martinique, was also opening new ways in painting, did not miss the opportunity to see what was happening in Montmartre, where his friend Bernard exhibited. Gauguin and Van Gogh had probably already met, the previous winter, at the home of the painter Maxime Maufra, but it seems that it was not till 1887 that the two most revolutionary painters of their generation really formed a bond. They were not so young anymore, both approaching forty (Gauguin was slightly older than Van Gogh), and they both took up painting when they were relatively advanced in years (Gauguin had first tried his hand as a stockbroker). They were both equally passionate, determined, and ambitious, and so began a friendship that gave rise to some lively discussion joined by Bernard and the Pissarros, father and son. The issue at stake was nothing less than the entire future of painting! Theo, urged by his brother, bought some of Gauguin's paintings and exhibited them in his gallery, before, two years later, taking him under his wing as well and encouraging him to go and stay with Vincent in Arles.

Gauguin brought with him some exotic images, a new way of looking at the world beyond Europe, a fresh vision that broke with the accepted ideas of academia (as opposed to the Orientalists who had had their own vogue), and empathized with "primitive" peoples. Vincent, for his part, was increasingly fascinated by Japanese art and continued to collect prints bought relatively cheaply from the dealer called Bing who ran a shop in Rue de Provence. They were both trying to break away from the all-powerful European tradition, to enrich themselves with other cultures, other visions of the world that did not seem so foreign to them as other people said. Soon, in Arles, their experiences were to bring them into more intense confrontation.

Before Le Chalet there had been Le Tambourin. It had probably been Toulouse-Lautrec who first introduced Vincent to this Italian restaurant run by Agostina Segatori, a former model of Gérôme and Corot. He and the mistress of the establishment became lovers. He paid for his meals with paintings, covering the walls with sunflowers. He painted her, not as his two colleagues had done as an example of a Neapolitan woman, as a paragon of Mediterranean beauty, nor with the affectation of the Impressionists, but like an ordinary woman, with the realism of a Toulouse-Lautrec. Leaning her elbows on a small, round table in front of a beer glass, she held the same pose as Poudre-de-

The cemetery at
Montmartre.
And then I will take myself off somewhere down south, to get away from the sight of so many painters that disgust me as men.
To Theo, summer 1887.

Italian Woman (Agostina
Segatori), Paris,
December 1887.
Musée d'Orsay, Paris.

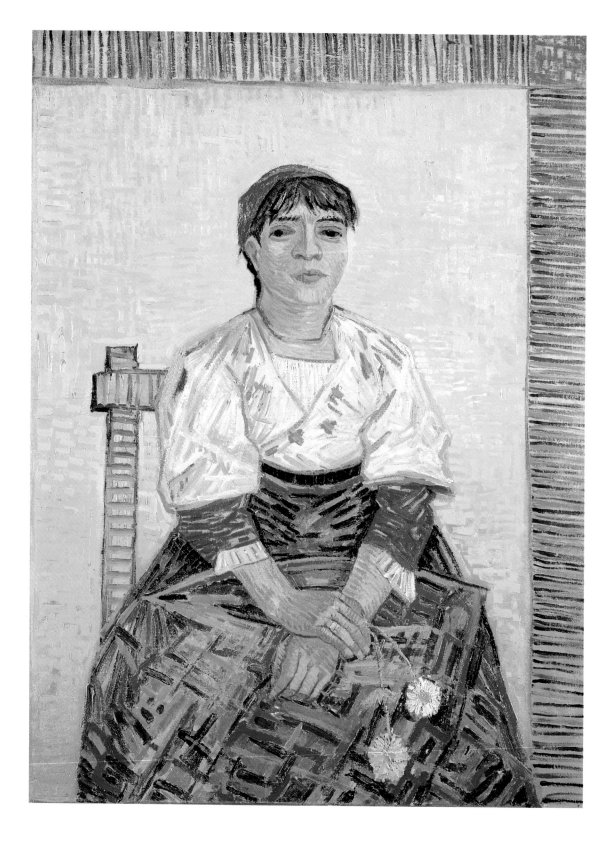

Riz, one of Lautrec's models that he had sketched that same year with refined, small, light brushstrokes, without the panache of the poster artist. The background is a study of large strokes in contrast to the sensual caresses with which Vincent applied his paint to the asymmetrical face tinged with sadness. In another canvas, *The Italian Woman*, there is no doubt it is the same woman wearing festive traditional costume, with the face handled in thick green mask lines on a pink background. Her face with wide red mouth, big eyes, and black hair on a straw-yellow background is cleverly framed on both sides by bands of parallel lines echoed, to a lesser degree, by the back of the chair. There is no longer the slightest trace of Impressionism here, no more tiny brushstrokes nor tender harmony, no more soft light, nothing but the presence, in all its splendor, of an opulent woman—and the proof of the Japanese influence, here perfectly controlled. Vincent, at Segatori's restaurant, before he broke off with her, leaving a few sunflowers as payment on account, had organized an exhibition of Japanese prints that helped make Japanese art known in the artistic milieu of Montmartre and the surrounding area. Ever since his arrival in Paris he had continued to study Japanese art in which everything seems to be literal, where the quality of the vision is only equaled by the boldness of the drawing and the color. Of course, he was not the first to be reduced by this foreign popular art, which had already impressed Paris in general and the Impressionists in particular, but there was still much to be learned from aesthetically. Émile Bernard, among others, was strongly moved by it.

La Segatori was hoping to sell some of Vincent's paintings, but she did not have any more success than Père Tanguy, who was probably more aware of their true value than she was, and whose portrait was also done under the Japanese influence, without the division of colors into tiny strokes or dots that is part of the Impressionist rule of complementary color. Tanguy's portrait shows him full face, peaceful as a Buddha, the large, flat, blue shape of his jacket dominating the center of the painting against a background entirely composed of Japanese prints. Vincent wrote in the letter to his sister Wil, already mentioned, what he hoped to achieve above all was a good portrait. He went on to say that what art required was a violently alive work in high color and of startling execution. He had planned to implement this twofold project as soon as he arrived in France, and he finally completed it in under two years just before he left for the South, where nature itself was to give him the spectacle of color.

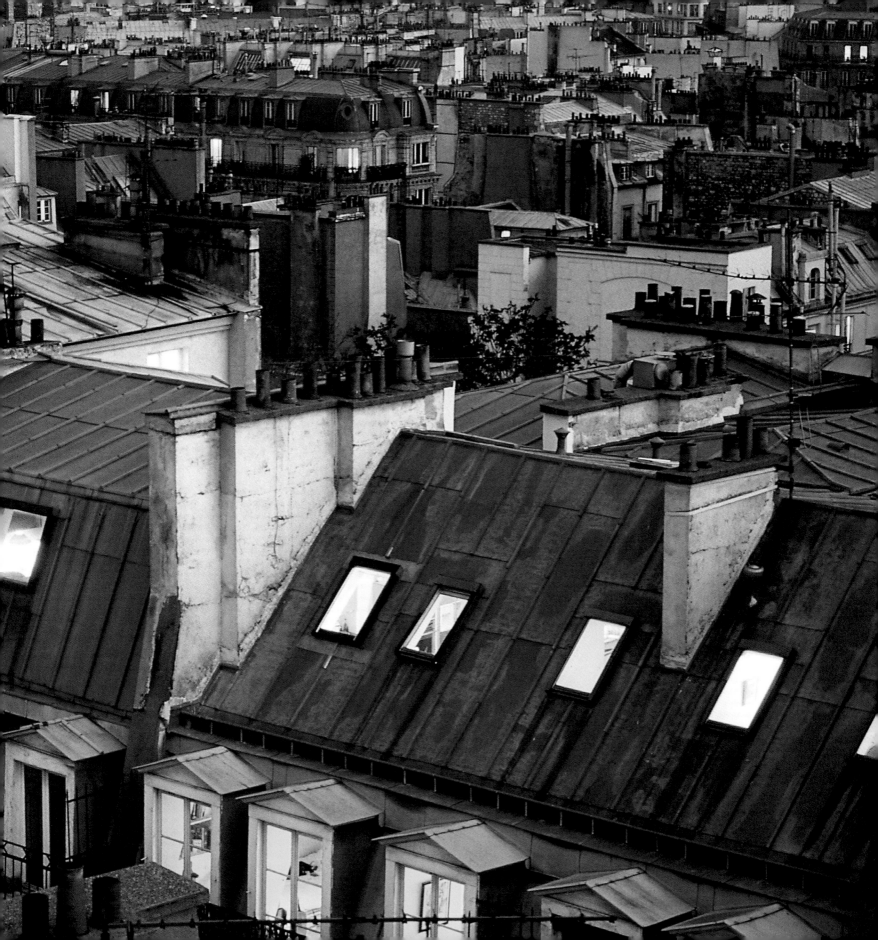

The little church at Zundert where Theodorus Van Gogh was the Pastor. *During my illness I saw again every room in the house at Zundert—every path, every plant in the garden, the views of the fields outside, the neighbors, the graveyard, the church, our kitchen garden at the back— down to a magpie's nest in a tall acacia in the graveyard.* To Theo, January 23, 1889.

From Northern Skies

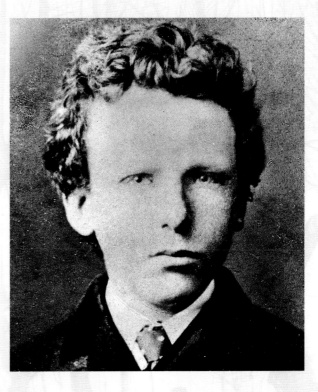

Vincent Van Gogh had difficulty trying to fit in. He wrote from Paris that one of the reasons he was living in France was because he did not feel at home in his own country, or even in his own family. This is understandable. It took him a long time to free himself from whatever attachments he had felt as a child, as a teenager, and as a young man to his parents, to the landscapes of his native Holland, and to the Protestant religion. He had to break away, to understand that he could only be himself elsewhere, in the kingdom of art, in the world of painting and color, far from the treatments, far from the churches where his pastor father, Theodorus Van Gogh, spread the "good word," far from the petit-bourgeois universe where hypocritical propriety was the rule.

Zundert is a town in the Brabant region of Holland not far from the Belgian border, seventeen kilometers from Antwerp. In the small old cemetery, at the foot of an elegant brick church, there is a tombstone bearing the name of Vincent Van Gogh. A child is buried there, a child who did not have the chance to live, a child who was born one year to the very day before that other Vincent who was his younger brother. The pastor who preached at that time from the pulpit that still faces the pews where the faithful sit, was their father. The second child who was born in Zundert on March 13, 1853, was a child with no outwardly remarkable features. He did not show any precocious talent, nor any special artistic disposition. He was well brought up in a large family with strict but affectionate parents. The uncles on both sides were professional men, notaries, in the church, the navy, or art dealers.

Vincent loved nature. He used to enjoy running through the fields and toyed with the idea of a career in the natural sciences. He was rather good at

Vincent Van Gogh. Rijksmuseum Vincent Van Gogh, Amsterdam.

. . . I keep looking more or less like a peasant of Zundert, Toon, for instance, or Piet Prins, and sometimes I imagine I also feel and think like them, only the peasants are of more use in the world.

To his mother, October 1889.

drawing, following the example of his mother, who skillfully sketched flowers and dabbled in watercolor. There was at least one reproduction of a work of art in the house, which hung on the wall of the pastor's study. It was *L'Enterrement dans les Blés (The Burial in the Wheat)* by Jacob Van der Maaten. A bas-relief on the house his family lived in, a statue by Ossip Zadkine in front of the small church, and a Vincent Van Gogh center maintain the memory of the painter whose posthumous celebrity projected him into the legend of art.

Vincent had two brothers and three sisters. He was the oldest. It seems he suffered emotionally more from the fact that he had ginger hair than from the fact that he had been preceded by a brother with the same name. He went to the village school for a time, then he stayed at home, where he received personal tuition, before being sent to a boarding school in Zevenbergen, approximately twenty kilometers from the family home, in an establishment that put great importance on languages. He was eleven years old and very unhappy, he later admitted, when the little yellow coach in which his parents had taken him there had departed. He was rather uncommunicative, but a good pupil. No doubt it was there that he

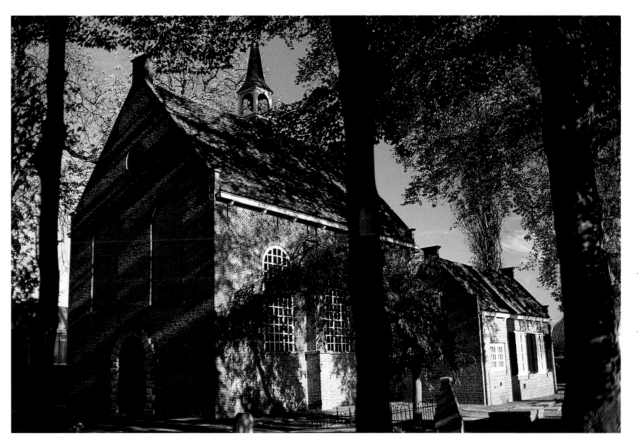

The grave of the first
Vincent, brother of the
painter, in the grounds of
the church at Zundert.

Church at Zundert.
*Who knows, we may shake
hands one day, as I remember
Father and Uncle Jan did one
time in the little Zundert
church, when uncle returned
from his journey; many things
had happened in both their lives,
and they finally felt, as it were,
firm ground under their feet.*
To Theo, June 12, 1877.

developed the taste for reading that never left him. It is evident throughout his correspondence, and it made him an extremely cultured artist.

Two years later, when he was thirteen years old, Vincent had to move farther away from the family home, to the town of Tilburg, where he was given more advanced instruction in a public secondary school. The school buildings were the former palace built for King William in 1849, shortly after Holland had become independent of Belgium, and which was an impressive example of Neo-Gothic pride. Today it is the town hall of Tilburg. The lessons were relatively modern in conception. Discipline was quite liberal, and art was taught four hours a week. C. C. Huysmans was not con-

tent to teach his pupils the laws of perspective and to show them how to copy academic plaster models; he took them outside to draw from nature, which must have pleased Vincent who was always happy to escape from being cooped up inside.

During the second year he spent at Tilburg, an event took place about which we know very little: the young Vincent Van Gogh suddenly returned home to Zundert. Was it a problem with his health? A problem of discipline? For fifteen months he remained idle, dull, solitary, until Uncle Cent, who was an art dealer, proposed a solution. Cent is short for Vincent, for this brother of the pastor Theodorus was also called Vincent. He had made his fortune in the art market by transforming

The Beach at Scheveningen.
Rijksmuseum Vincent
Van Gogh, Amsterdam.
It has been so beautiful in
Scheveningen lately. The sea
was even more impressive before
the gale than while it raged.
To Theo, August 1882.

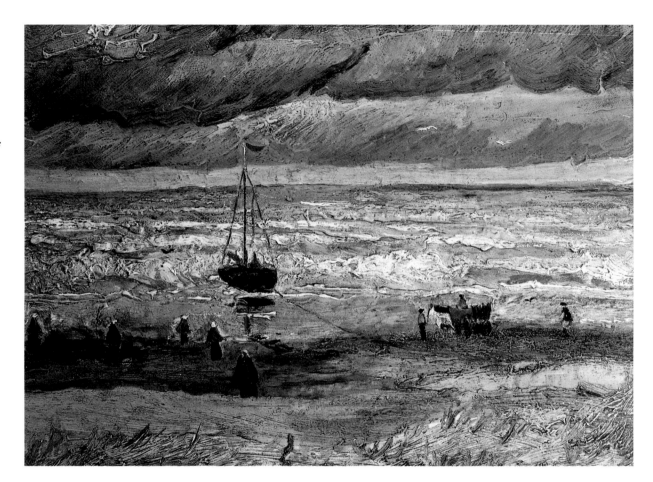

a cousin's painting-supplies shop into a gallery, and acquiring a collection of paintings by artists of the Barbizon school. He had become the associate of a Parisian engravings dealer, and lived in a private mansion in Neuilly. During the holidays, he often came to visit his brother Theodorus, the pastor, to whom he was very attached. Since young Vincent wasn't doing anything in particular, and didn't seem to have any plans for his future, but seemed to have a taste for art and for culture, he made him an apprentice in his former gallery in The Hague, which was at that time the Goupil Art Gallery. It was housed in an impressive four-story building, and directed by Hermanus Gijsbertus Tersteeg.

Vincent was by now sixteen, and both the town and the profession he was an apprentice in, which he liked well enough, were new to him. He lodged with friends of his parents, who kept an eye on him. The Hague, surrounded by woods, and right next to the sea and easily accessible to the port and beaches of Scheveningen, was a pleasant little city frequented by a few keen landscape artists. It was popular to the extent that people spoke of "The Hague School." So it was that Vincent developed a taste for art and the North Sea at the same time. He visited the Mauritshuis Museum, which, although recently opened, already boasted some superb paintings by Rembrandt (*The Anatomy*

Lesson), Rubens, Jan Bruegel, Holbein, and others. It was probably not long before he had to go to Amsterdam, which is not far from The Hague, and where he had uncles he could stay with, to view the national collections that were housed in the Trippenhuis until the building of the Rijksmuseum was completed. It seems certain, at least, that Van Gogh went there in January and March 1873. He also became familiar with the art of his own century, for there were many paintings exhibited or stored in the gallery of Goupil & Cie. They were mostly works by contemporary Dutch artists, but also a few French masters, including the celebrated Baron Jean-Leon Gérôme. Vincent and he were later neighbors in Paris, and Vincent often passed his studio in Boulevard de Clichy, without ever going in.

At that time, prints made from engravings were the main means of reproducing paintings, so that they could be seen all over the world by a public that was growing due to the prosperity that the bourgeoisie enjoyed as a benefit of the Industrial Revolution. Vincent was soon assigned to the sale of prints and he took his responsibilities to heart, quickly becoming a connoisseur of ancient art and of what he believed to be modern art. He developed a passion for Jean-François Millet and Jules Breton, who later became two of his greatest mentors beyond his experience of Impressionism, right up to the end of his life. He also got to know some of the painters who frequented the gallery, such as Jozef Israëls, Jacob Maris, and Anton Mauve, who gave him moral support a few years later when he was starting his career as a painter. For the moment, Vincent was not tempted in any way to cross the border that separated artists from art dealers, and his drawings were simply a means of

taking notes or of illustrating ideas that could be made clearer by a sketch

Unfortunately, we have no direct records of Vincent's thoughts or experiences during the first three years he spent in The Hague. The abundant correspondence he exchanged with his brother only really began in earnest in January 1873, when Theo took up employment at Goupil & Cie in the Brussels branch of the firm. A few months earlier,

Vincent himself had gone to the Belgian capital, to visit the annual Salon for that year; among the usual hackneyed nonsense of academicism, three paintings by Edouard Manet and one by Claude Monet were being exhibited. It seems that they did not make a particularly strong impression on Vincent. In May 1873, he returned to Brussels and saw his brother, but did not stay for long. He had come from Helvoirt, another village in the Brabant, nine kilometers from S'-Hertogenbosch (the native town of Hieronymus Bosch), where his father had recently been nominated as the head of a congre-

Yesterday (Sunday) afternoon I went to Baarn with Uncle Jan. How beautiful it is there! We walked through the avenues of pine trees and beeches in the wood, and saw the sun set behind a coppice.

To Theo, May 21, 1887.

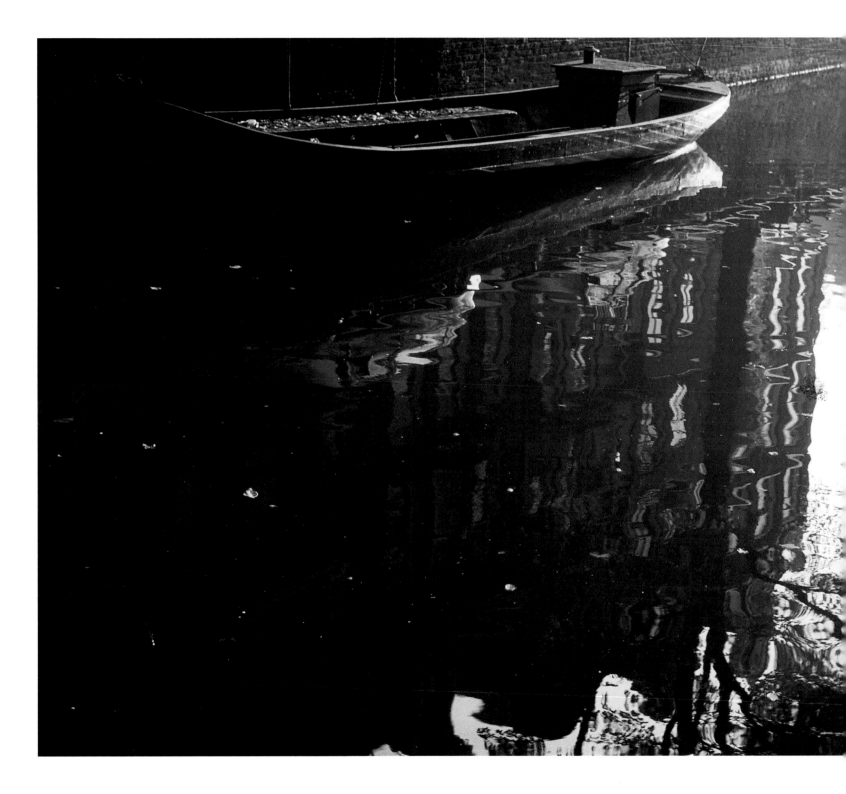

gation that possessed an ancient 15th-century Gothic church. He had gone there to visit his parents before leaving for London.

Four years later, it was quite a different Vincent who returned to Holland, who came this time to Etten to see his parents. Theodorus's job had taken him to this other town in the Brabant. Did he know when he left Isleworth in England that he would never go back? This is far from certain. He had begun his work as a lay preacher, and it would seem that he made the decision to leave England partly due to pressure from his family and partly due to the intervention of Uncle Cent, who provided him with an opportunity of employment as a clerk in the book shop of Blussé et Van Braam in Dordrecht. He did not, for all that, abandon what he perceived at this point to be his vocation, and remained obsessed by the Bible, which he read constantly, both at work and during the brief moments he spent in his rented room on the Tolbrugstraatje. Dordrecht is a town in southern Holland, approximately fifty kilometers from The Hague. It is a major river port and one of the oldest cities in the country. The banks of the Oude Maas, and the various canals, busy with barges, are delightful, and it seems that Vincent liked this town, the birthplace of Ary Scheffer, a painter who became famous in France in Louis-Philippe's time, and who had had a Parisian studio near the Place Pigalle.

In his letters to Theo, Vincent says little about Dordrecht, gives no picturesque descriptions and rather just continues, monotonously letter after letter, an interminable sermon in which he repeats religious clichés with hardly any personal sentiment whatsoever. He briefly mentions the landscape he could see from the window of his bedroom, gardens planted with pine and poplar trees,

A few days ago two children fell into the water near the Kattenburg Bridge [...] They dragged the little boy out [...] every effort was made to revive the child, but in vain.
To Theo, July 27, 1877.

a few old houses, a dike alongside windmills (no doubt the Kinderdijk windmills), a path behind the station, and the cemetery. He said he liked this country, his country, and felt it was possible there to strike up an alliance with the Lord. He also makes allusions to the works of Ary Scheffer, which the artist donated to his native town, and which are still exhibited at the municipal museum. However, he didn't mention the Gothic church that had a chime with forty-eight bells, nor the coopers' harbor, nor the grand hotel that is today the Simon van Gijn Museum, nor the Fihs bridge, nor the beautiful houses at the old vegetable market, nor the picturesque Vijnstraat. This young man of twenty-four lived an austere life, did not laugh, did not eat meat, and mumbled his prayers all the time. He still wanted to be, more than ever, "a sower of the word," maybe even a pastor, like his father.

In May 1877, he was in Amsterdam, a town he was already familiar with. He had often gone there to see his Uncle Cor, who was also an art dealer like Uncle Cent and lived on the Liesestraat, and Uncle Jan who was director of the boat-builder's yard and who put Vincent up at his home on the harbor. A third uncle, on his mother's side this time, was responsible for looking after him in this venture, and helping him to study for the entrance exam that he had to pass before he could undertake the studies that would qualify him as a pastor. Greek, Latin, and mathematics were three subjects in which he would have to work extra hard to attain the required level, and he beat himself with a stick when he was not satisfied with his work. For fifteen months he struggled under the instruction of two excellent teachers, although he was not convinced that mastery of these disciplines was necessary for someone who simply wanted to

spread the word of God. Wasn't it more important to absorb himself in the Bible and in *The Imitation of Christ*, or to go around to the religious establishments listening to all the sermons being given there, and not just confining himself with listening to teachings of Uncle Stricker at the Oudezijds Kapel, at the Amsterkerk or the Eilandskerk? He was obsessed by religion, he wanted to be a pastor, but in his own way. He was already rebelling against the institution from which he was seeking recognition. He had not turned his back on painting entirely. He still visited the Trippenhuis, or he would buy print reproductions of famous paintings. However, he was developing a religious conception of art, seeking in art the illustration of the sacred texts, the praise of a God of love of whom all nature was proof positive.

In Amsterdam Vincent Van Gogh meditated long and hard on the foundations of life and on what could give life meaning. Faithful to his habit of being a great walker, which, in England, had him eating up the miles, he liked to wander, every day, in and around the town, contemplating the landscape and letting the thoughts drift in and out of his mind. "I like to wander through the old streets, narrow and dark, where there are pharmacies, lithographer's workshops, other print shops, merchants of sea maps, boat-supplies shops, etc." He was particularly fond of the Buitenkant quarter. He also used to go and look at the elms and windmills not far from the station. He walked along the Zeedijk, the Warmoestraat, the Niezel. He went to the cemetery near Muiderpoort. He went to the flower market on the Singel, a famous canal. He went into the Harterstraat to look for books and cards, to the shops of Schalekamp and Brinkman. He went along the edge of another

cemetery, the Jewish cemetery, then walked as far as the sea. At that time the countryside was never far from the town and it was to the countryside that he was always drawn. To Baarn, for example, on the banks of the Ij, where Uncle Cor had a house. He was even known to walk as far as Zuiderzee, as far as Zeeburg.

Vincent Van Gogh wrote from Amsterdam to his brother Theo on September 4, 1877: "It often seems to me that I already feel a blessing and a change in my life." He had given himself two years to catch up on his studies, but even before this time had elapsed he was forced to admit to himself that he had no chance whatsoever of success. What was worse was that had he lost the desire. His teachers were categorical; it was obvious that Vincent would never be a pastor. He later confessed to his brother that he had turned his back on a Faculty of Theology that seemed to him to be nothing but an "inconceivable gambling den," "a culture medium of Pharisees." He left Amsterdam and went back to stay with his parents. However, he was still determined to devote himself to religion. The training for lay preachers in Holland was long and difficult, but at Laeken, near Brussels, a seemingly more flexible school had just been founded, in which he could perhaps enroll. Vincent attended a course there for three months, at the end of which time, he once again had to face up to failure. He would be allowed to follow the courses at the school free of charge, but he would have to pay for his food and lodging. Financially, this was totally impossible. However, at his father's insistence, it was agreed that he be sent to an underprivileged mining area called the Borinage, near the French border, as an assistant, with no remuneration. He left Brussels

Before I went to Stricker's, I walked through the Jewish quarter and along the Buitenkant, the old Teertuinen, Zeedijk, Warmoestraat, and around the Oudezijds Chapel and the Old and South churches, through all kinds of old streets [...].
To Theo, August 18, 1877

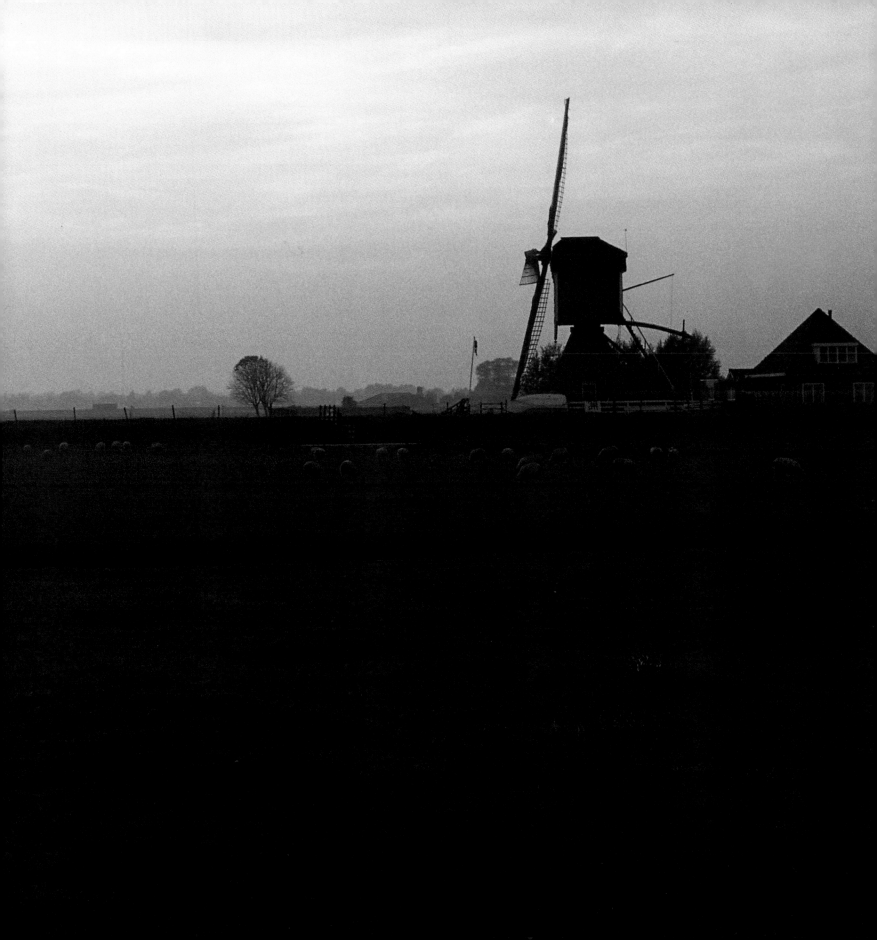

Derelict mine in the
Borinage.
Most of the miners are thin and
pale from fever; they look tired
and emaciated, wheatherbeaten
and aged before their time. On
the whole the women are faded
and worn.
To Theo, April 1879.

saying: "If I leave this city, I will not set foot in a
big town again for a long time."

And so, on Christmas eve, 1878, he arrived in
completely new territory for him, and he was as
yet unaware of how intense an experience it
would prove to be. It was snowing. He saw the
landscape through the eyes of an art enthusiast,
evoking Bruegel, Dürer, Israëls, Bosboom, Maris,
Meissonier, describing the curious spectacle of the
stark contrast of the jet-black miners emerging

after their day's toil into the background of snow at
dusk. He found a room in Pâturages, a small village
of thatched cottages, at the house of a peddler, right
next to the Saint-Michel church; but it was most
often in Wasmes, above the Marcasse pit, in a com-
munity room known as the "Baby's Room," half an
hour away near the woods of Colfontaine, that he
spoke about the Lord to the miners' families. They
lived in extreme poverty in wooden huts and in
coal dust close to the mines where they worked

practically like slaves; even children as young as eight were forced to descend into the dark and dangerous tunnels. Vincent wanted to share their existence, brothers in God. A baker on Rue du Petit-Wasmes took him in. He gave away everything he possessed, even his clothes, except his basic essentials. He ate scarcely anything. But he still felt that he was too richly endowed and decided to move into a wooden hut. Pastor Theodorus, who must have been informed of his son's fanaticism, came to see him and got him to agree to stay at the house of Denis the baker, and keep "the hovel he had rented" as a studio and workshop. He had covered the walls with prints that he had brought with him, for art was always his reliable companion, a constant point of reference for him. For, here better than ever before, he was able to establish a relationship between art and reality. For it was becoming increasingly clear to him that the role of art was exclusively to bring to the attention of the world the suffering and the dignity of the people on this earth.

Jesus was not the only voice who had called Vincent to the Borinage. There were also the voices of Jean-François Millet and Jules Breton, two major artists of popular realism. And so he was able to write to Theo: "*Art is man added to nature*—nature, reality, truth, from which the artist makes the meaning stand out, the interpretation, the character that he expresses, that *he frees*, that he untangles, that he enlightens." When he lived in the Borinage, Vincent Van Gogh had not yet taken up painting, but he had already very precisely formulated the theories of art that he would later adopt, that he would illustrate a few years later, in all the splendor of his genius.

In the countryside, on the surface, were gar-

dens and fields surrounded by hedges and brambles, thickets and oaks, and pruned willows. And, below the surface, was the mine, which he descended to a depth of seven hundred meters. The mine and its men, thin, ill, and worn out, "tanned and aged before their time," the mine that in furious fits of anger buried men alive, transforming Vincent into a first-aid man, to which he fully devoted his energy and his time. There were penury and suffering and the incredible power of art: "Around the pits are the miserable shacks of the miners and a few dead trees, blackened by the smoke, hedges of brambles, piles of rubbish and ash, and mountains of shale. Maris would make an admirable canvas of this." Vincent himself did a few sketches, to fix a few incidents in his memory. He read Shakespeare, Aeschylus, Michelet, Hugo, Dickens, etc. because, as he said, he needed to be constantly learning.

People found him eccentric. Some even said he

The country and the population seem more and more attractive to me every day. One has a homelike feeling here, like on the heath, or in the dunes; there is something simple and goodnatured about the people.
To Theo, March 1879.

was mad. Six months after Vincent arrived in the Borinage, the pastor who came as an inspector wrote a very negative report: the assistant lay preacher, he said, was performing charitable acts, but he was not a good enough orator, and his neglected appearance was not in keeping with the image of his position. Hadn't Theo himself taken him to task, criticizing him for acting as if he had private means and yet neglecting his appearance? Vincent's contract was not extended. He nonetheless believed that he had found his vocation and would not back down. In religion as in art, he again rejected the academic mold.

He set off on foot for Brussels, a wad of drawings under his arm. He showed them to pastor Pietersen, who was also an amateur artist, whose workshop he had already visited. That day the pastor had shown him some sympathy and did not discourage him.

Vincent came back to the Borinage, staying in another village, Cuesmes, in Pavilion Street, with the family of a miner called Decrucq near the Agrappe mine which, a short time before, had suffered a terrible methane explosion. Today, in a small, charming, isolated wood the house remains intact because it was saved in the nick of time from being swallowed up by the marsh. Visitors are welcomed there and reproductions of Vincent's works are on display and can be purchased. He would never give in to despair, would continue to choose to be "actively depressed"; he would maintain the "melancholia that hopes and seeks." He would become an independent missionary and would sketch the miners. He applied himself to a course of self-instruction in draftsmanship, the Bargue method. He shared his room with the children of the family. He was cold and hungry, despite the money his parents sent him: he gave most of it

away, keeping only a strict minimum for himself. He made more and more sketches. He was "homesick for the land of paintings." He wanted to go to Barbizon, where he would find an artists' community. In the middle of winter he decided to go, but less far—to Courrières in French Artois to see Jules Breton for whom he had had great admiration for a long time, and whom he had once met at the Goupil Art Gallery. He took the train to Valenciennes and covered the rest of the distance on foot. He found the house of the famous painter, stopped in front of a brick wall, and turned back. He went into the church and admired a copy of *The Entombment* by Titian. He found the French sky "more fine and limpid than the smoky, misty sky of the Borinage." And back he went, sleeping under the stars, to Cuesmes, where he sketched all the more, copying Millet and a few others, practicing figures, sketching "miners," speaking less and less about religion and more and more about art, finally becoming an artist himself at the age of twenty-seven. A few months later, he resumed his correspondence with his brother. It had been temporarily interrupted due to a difference of opinion that had arisen between them. Everything changed for him at that time.

He set off for Brussels again in October 1880. No longer in search of lay preachers, he wanted to meet artists. He was returning to a city he had once sworn he would never go back to. He found a room at 72, Boulevard du Midi, that he paid for with the help of his family, who were not displeased to see him turning over a new leaf. He ate bread, potatoes, and chestnuts. He met the painter Anton Van Rappard to whom he had been recommended by Theo and who graciously agreed to give him lessons in his studio in the fashionable

The State Lottery Office, The Hague, September 1882. Rijksmuseum Vincent Van Gogh, Amsterdam.

quarter of Saint-Joost-ten-Noode. He also arranged for some workers and children to pose as models for him. He was hoping, one day, to earn his living from his sketches.

However, he ran out of money and was forced to return to his family in Etten. He stayed there till the end of the year, finding new inspiration as far as possible in the countryside, painting from nature, drawing a shack on the heath, windmills or the elms in the cemetery, the heather, the wood-cutters, and farm implements. Van Rappard came to see him and they went and worked together "from nature." Then Vincent traveled to The Hague to see the painter Anton Mauve, who welcomed him cordially and encouraged him to graduate to brushes and color. He was therefore finding a firmer grounding in his new life as an artist, and his parents accepted his bohemian behavior as

best they could. Until August that is, when his cousin Kee, the daughter of pastor Stricker, came to stay in Etten, with her small son. She had just lost her husband. Vincent, who had been friendly with her and her husband in Amsterdam, fell head over heels in love with her, made his feelings known to her and was instantly rebuffed. The cousin fled, but the artist did not give up and reveled in the feeling that possessed him to the extent that he proclaimed to his brother in November: "Melancholia is for those who want it; as for me, I've had enough of it, I only want to be gay like a lark in spring." He was persistent. He followed her to Amsterdam because his letters remained unanswered and turned up at the home of his Uncle Stricker. The pastor showed him the door and in order to impress him, Vincent deliberately burned his hand on an oil lamp. He found temporary consolation with a prostitute in The Hague. He had gone there for a month to take some lessons in painting from Mauve and was thinking of moving the following January. This he did, and much to the annoyance of his father refused to attend the Christmas service before he went.

The pastor threw him out and he went straight back to The Hague, which he described as the center of artistic life in the Netherlands, to resume his lessons with Mauve. He found a place to stay in an expanding suburb of Schenkweg in which he drew the eclectic mixture of farms, hangars, factories, gas-tanks. He studied at an art school, the Pulchri studio, where he was able to study life drawing. Theo sent him money. He had a liaison with a prostitute, Christine, known as Sien, who had one child and was expecting another. He did a nude portrait of her, which he christened *Sorrow*. Uncle Cor commissioned him to paint a series of views of

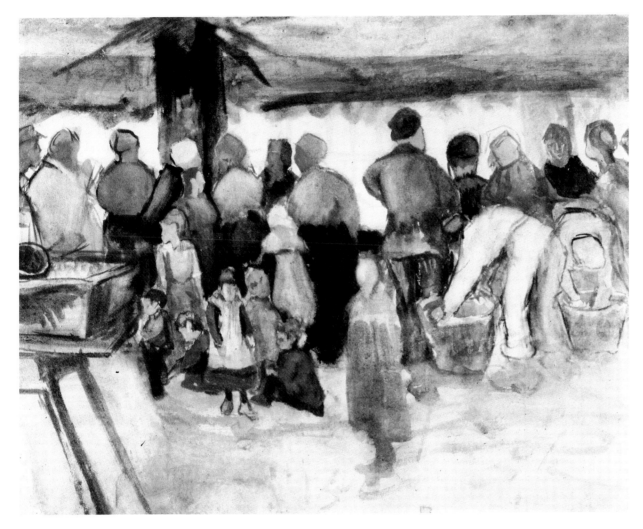

The Fishmarket,
watercolor. Private
collection, Paris.
Well, my youth appears to have
passed—but not my love of life
or my energy. What I mean is
the time when one feels so
lighthearted and carefree. So
much the better, now that there
are much better things.
To Theo, January 1882.

The Hague, for which he paid a very low price. It was more akin to charity than patronage. Vincent was not able to work very fast due to the bad weather. This commission was the bread-and-butter work that prevented him from doing what he really wanted to do, which was to paint figures. He was sorry to see, both in London and in Brussels, the destruction of all that was ancient and picturesque, but he liked to observe and to sketch people in the street, men working, ditch diggers, old people from the old people's home, the people in the third-class waiting room, in front of the lottery office, or on a church pew. He drew the Rhin station, the fish market (the Geest), a gas factory, a carpenter's hut, a fish-drying plant at Scheveningen, the potato market at Noordwaal. He was echoing the *London* of Gustave Doré.

He fought with Mauve, who called him stupid for spreading oil paint with his fingers. In a fit of rage he smashed the plaster models that he was

forced to copy, but another painter, Van Rappard, congratulated him on the progress he was making. Seen today, the drawings Vincent did at that time show that he was obviously already an extremely talented draftsman. He had to go to a hospital to be treated for gonorrhea, and he set up home at 136 Schenkweg, with Sien, who had just given birth to a baby boy. He had met her in January on the streets. He wanted to save her. He did some admirable portraits of this woman he called "faded," whom he thought he loved. She posed meekly for him and the results were a dense, grave likeness wrought with sharp, controlled lines. He imagined that he had a vocation as head of the family, but he was penniless.

His drawing progressed. He had truly become an artist. He had his own studio. He would earn a living at this. He sent drawings to Theo in exchange for the money he received from him. He considered that his impressive collection of prints from now on belonged to his brother. He sketched in the town and in the countryside, in the woods, in the Schenkweg, in the pastures at Rijskwijk, in the potato fields at the Laan Van Meerdervoort, among the chestnut trees of the Bezuidenhout, in the dunes at Scheveningen where he watched the boats come and go, where he watched the sea in a raging storm. He lay down in the sand, kneeled in the mud. He had a special frame made from a design borrowed from Dürer to study perspective. He was learning about color, watercolor and oil. He put his whole life and soul into it, to use an expression from Millet. He also tried his hand at lithography. He wrote long letters to his brother, and to Van Rappard, giving details of his material, aesthetic, and moral con-

The dunes of the North Sea.

But I repeat: everyone who works with love and intelligence finds a kind of armor against the opinion of other people in the very sincerity of his love for nature and art. Nature is also severe and, so to speak, hard; but she never deceives and always helps us on.

To Theo, July 1882.

Memories of the North, 1890.
Rijksmuseum Kröller-
Müller, Otterlo.

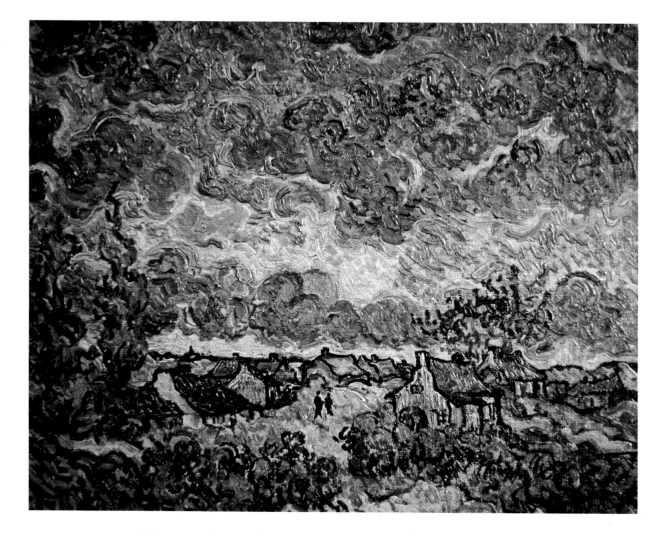

cerns as an artist fully committed to his art. He declared that the painter's duty is to mingle completely with nature, to use all his intellectual faculties and to translate all his feelings into his work, in order to make it accessible to others in both figures and landscapes.

This euphoria lasted for eighteen months, then his happiness and his hopes gradually faded away. Sien was no longer selling herself, and her mother also had to be fed. There was no money, and Sien was preparing to take up her former profession

again. Life became impossible. Van Rappard was painting in Drente, a pretty region in the north, and he wanted to go and join him there. City life decidedly did not agree with him. Towns were not made for painters. He left The Hague, alone, on September 11, 1833.

He had looked at the map. He knew there were peat bogs, a Black Lake, the town of Hoogeven, the canal of Hoogeven, villages, hamlets called Osterheuvelen, Erica, Stuifsand, Zwartschaap. He was hoping, in this area, to make great advances in

his painting. He thought he would spend the winter there, but in the end he stayed only three months. The time came to turn a page—the page of The Hague. He made up his mind that it was no longer enough to be just an illustrator in black and white; he would have to be a painter, which means that deep within himself he already was a painter, albeit a painter who still had a lot to learn. The Drente was a necessary retreat, which was beneficial after the double disappointment he had experienced in affairs of the heart. He took a room in an inn in Hoogeven and quickly started to go for walks in the countryside, sketching thatched cottages in the heather, a cemetery with white stones, observing the country people, the peat gatherers, the shepherds of this region with their flocks, the "primitive" state of which struck a chord with him. He paid a few models to pose for him in the fields, and they laughed at him. Then he went to Nieuw Amsterdam, by boat, and made a few sketches of the other passengers. There was a magnificent sunset on the heather, on the windmills, on the drawbridges over the canals. The landscape was beautiful, peaceful, and at the same time, tragic. He did drawings of old oak roots. He exclaimed that he thought he had found his niche. He found a studio to work in when the weather was dull. His courage came back to him; he had faith in

The house where Margot lived, the neighbor in Nuenen who was in love with Vincent.

Of myself I believe—and I think it possible that it is the same with you—that I have not yet had enough experience with women. What we were taught about them in our youth is quite wrong, that is sure, it was quite contrary to nature.

To Theo, February 1884.

painting and confidence in his future as a painter. He wrote to Theo that he was becoming "a painter by painting," and he added that the province of the Drente was so beautiful, and had captured him so powerfully, so completely, it satisfied him absolutely. He also said that if he could not stay there forever, he would rather never have seen it. He went to Zweeloo. On the way, he saw scenes similar to those painted by Corot. In this country that he described as being "nothing but land to infinity," he saw everything in color—"reddish grays, bluish grays, dark lilac grays, yellowish grays, shades of unspeakable purity among the green of the wheatfields—black on the wet tree trunks from which the leaves fall like golden rain in autumn." He found there "serenity, faith, and courage."

During this time Theo, too, was experiencing emotional and financial difficulties; he was thinking of emigrating to America. Money, for the two brothers, the artist and the art patron, was a problem for which there seemed to be no solution. Vincent overcame his solitude, that loneliness that strikes a painter whom both outsiders and his peers consider mad, by writing endless letters to his brother, full of sketches, in which he urged Theo to become a painter, too, and come and join him; or he would plan to go to Paris and earn a living at a printer's. In the end, he left the Drente, and went to Nuenen, where his parents were now living and where he could live more cheaply. In the meantime, he left his belongings in Nieuw Amsterdam, no doubt intending go back there. But once he had traveled all the way across the Netherlands, and reached the Brabant, he had no money left for the return journey. He changed his perspective.

Nuenen is a charming little town today. It has

shown no resistance to modern architecture with its elegant comfortable houses, dispersed under the trees. At that time, it was only a modest town with a Catholic church and a Protestant church. A town of farmers and weavers. Today, there is a statue of Vincent by Klaas Rosimalen in the town center. The tourist information center, bearing the name of Vincent Van Gogh, guides the visitor through the village and surrounding area. There is a commemorative stone near the house where his parents lived, an attractive middle-class house in the center of the town, not far from the little church where the pastor preached his sermons. At that time, people laughed at the painter who looked like a tramp and at the father, who did not believe in his son's late-found vocation, or in his

OPPOSITE. Vincent's parents' house in Nuenen.

ABOVE

The Potato Eaters, Nuenen, April 1885. Rijksmuseum Vincent Van Gogh, Amsterdam.

Outside of the Church in Nuenen, October 1884. Rijksmuseum Vincent Van Gogh, Amsterdam.

OPPOSITE

One of the last Windmills in Nuenen.

It is true that the inhabitants of this countryside make the facts and their gestures coincide with the priest's exhortations, but they do it in such a way that I discover I have no scruples whatsoever about accepting this. To Theo, May 1884.

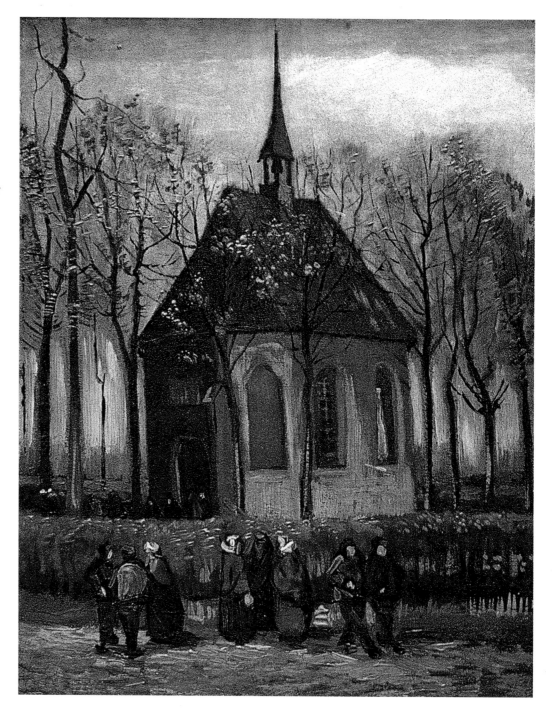

artistic talents. The father who could no longer regard him as anything more than a failure. He despaired of him and was ashamed of his awkwardness, but during this enforced stay and in the condition that he was in, Vincent for a short time regained the affection of his parents. He was given a room where he could paint, a "workshop in a coal shed, with drains and a dry toilet." He took tender care of his mother when she broke her leg and had to stay in bed. He was at least hardworking, and that was enough to command respect. He painted the church, an old tower which was destroyed shortly afterwards, some country folk, and weavers. He drew the windmill that still stands proudly in the north of the town. He painted an imposing watermill that still stands superb and monumental today—two silent witnesses to a time when the natural elements were all that was needed to run machines.

He needed more space and a place of his own, so with money given to him by Theo he rented two rooms from the Catholic sexton. Theo reviewed their arrangement and put his assistance on a more businesslike footing. Vincent reproached his brother for giving him charity without really taking an interest in his work. Occasionally, he would go to the nearest town, Eindhoven, where he would meet other artists at the paint shop. One of them even asked him for some lessons. He commissioned six panels for his dining room, which he would then only have to copy himself, and then somehow omitted to pay for them. Vincent took some piano lessons because he had heard an intriguing theory of the possible interrelationship between color and musical notes (this was the dawning of symbolism). He probably also visited some women there, for they were not very expen-

Watermill in Nuenen.

sive. He forgot about Sien. The important thing was painting. Work. To make up for his late beginning, he was determined to succeed. He wanted to paint the weavers. There were fewer paintings of them than of the miners. He would become the painter of the weavers leaning over the enormous looms that they seemed to became a part of. He also wanted to paint the summer, which he said was "not easy to express" and which is entirely 'in the opposition between the blues and the element of orange or golden bronze of the wheat." Another amateur painter sometimes accompanied him when he went out into the country to paint from nature.

In the month of October, Van Rappard came to spend ten days with him and they resumed their long discussions, exchanging experiences. Theo also came and brought him up to date about what was happening about Impressionism in Paris.

Theo was now one of the most ardent supporters of Impressionism since Boussod & Valadon, the new name of the former Goupil & Cie, had given him a free hand in part of their gallery. When it was winter again, Vincent was able to recruit a few models among the country people who had less work on their hands. He wanted to capture personalities and bear witness to their life, to their reality, to their dignity. He wanted to create paintings that were full of life. It was the De Groot family that posed for *The Potato Eaters*. It was a long, difficult undertaking with several preliminary sketches before the final work was completed. He recognized it as a major work, the one which would finally make a painter of him in the mold of Millet.

Father Theodorus Van Gogh died on March 26, 1885. It was a shock for this son who

loved him so much, in spite of everything. Vincent was wrongly accused of having got the De Groot daughter pregnant. He had already been accused of having a liaison, which was no doubt platonic, with Margot, a neighbor, a spinster who had fallen for him and who wanted to marry him. She made an attempt to kill herself, and the Catholic priest solemnly forbade his parishioners from posing for this painter who was in league with the devil. In October, Vincent went to Amsterdam to look at

some paintings again. He spent hours contemplating Rembrandt's *The Jewish Bride*. And, in the month of November, he set off for Antwerp, where he wanted to follow the teachings at the academy.

He was soon at odds with this academic institution where the teachers sneered at everything he showed them. He wanted to recreate the pink cheeks painted by Rubens, the great master of Antwerp. He discovered Japanese art, woodcuts, in a few good shops. He painted nudes in an alternative art school where young painters got together to share the fee for live models because the academy wanted nothing to do with such obscenity. He caught syphilis. Then he had only one desire—to go to the home of the new style of painting, where Theo was living, where he would be less alone and better understood—to Paris.

On February 28, 1886, Vincent Van Gogh left the north forever. He was going to France, where the light was brighter, where painting was younger. He left the north never to forget it, but unaware that he would never return. Later, after the Impressionist adventure and his trip to the south of France, he began to feel homesick, and he knew that he would have to return but he didn't have time. He didn't have the strength. He died, too soon, at Auvers-sur-Oise.

The Old Cemetery Tower in Neunen. May 1885. Rijksmuseum Vincent Van Gogh, Amsterdam. *I wanted to show ruins where for ages the peasants have been laid to rest in the very fields that they dug up when alive; I wanted to express what a simple thing death and burial is, just as simple as the falling of an autumn leaf [...].* To Theo, June 1885.

OVERLEAF

Nuenen landscape.

Conclusion

Vincent Van Gogh took his own life. Antonin Artaud, identifying with the mortal rejection the painter suffered, wrote that Vincent's suicide was "social." But Artaud himself was much more tortured by the forces of darkness, and seeing Van Gogh from the perspective of his own experiences, he pushed the tragic element of the story to the extreme, inventing a *pictor dolorosus* fiction of over-exaggerated romanticism. Vincent couldn't have been as mad as all that, considering the power he wielded through his brush in such a short space of time. A close look at Van Gogh's painting today, following the paths along which his adventurous existence took him, reveals a happy, radiant man, alive with experiences, relentlessly expressing his appreciation of the world as we know it, *the here and now.*

Even when he was trying to become a preacher, he showed less spiritual attachment to a world of mysticism than he did evangelical affection for the earth, the most beautiful of all kingdoms.

On the Finistère coast, where the extreme west celebrates the union of land and sea, Kenneth White imagined a visit from Vincent Van Gogh. From this fantasy the writer, whose work is among the most serene of his time, drew a tale that rings startlingly true: taking the painter's passion for Japan literally, he portrays a Van Gogh who is Zen, smiling, clear-minded, and offers us the most luminous styles of painting. Like Sisyphus, surely Van Gogh was happy. He invested his painting with all of the confidence he had in nature, which for Vincent meant the world and people. Van Gogh took pleasure in his painting; it expresses his joy and his exaltation. Van Gogh gave us the gift of his painting to help us to see better, and to live better lives.

Treading Sacred Ground — Auvers

A Small Tourist Guide

Since Sunday I have done two studies of houses among the trees. A whole colony of Americans has just established itself next door to the house where I am; they are painting [...].
To Theo and Jo, June 1890.

TREADING SACRED GROUND — AUVERS

Situated at 30 kilometers to the north of Paris, Auvers-sur-Oise cherishes the memory of Vincent Van Gogh, who spent the last months of his life in the village and finally killed himself there. Several decades earlier, Charles François Daubigny, who was born not far away at Valmondois, had already made Auvers popular with artists, attracting Corot and Daumier. Later, Doctor Gachet, a homeopathic doctor and himself a keen amateur artist and supporter of Impressionism, enticed Pissarro to come and live in nearby Pontoise. Pissarro in turn brought Cézanne, and the artist from Aix spent eighteen months at Auvers where he created some of his most famous paintings. Henri Rousseau, nicknamed Le Douanier (customs officer), also set up his easel in the vicinity.

The village, soothed by the gentle flow of the river Oise, has kept all its charm and tranquillity today.

The village can be reached in under an hour from Paris by train, with one change at Pontoise. You descend from the train at Auvers station, which was painted by Vlaminck some years after Van Gogh's death. When Vincent came here for the first time, he got off the train at the previous stop, the Halte de Chaponval, which was closer to the house of Doctor Gachet. It is possible to reboard the train from this stop after walking the length of Auvers, which sits on the bank of the river Oise. The railway follows the course of the river at this point.

Everything of interest in this location is clearly signposted. At every strategic spot in this cultural center of painting, which has been a great meeting place for artists since the middle of the 19th century, there is a signpost with a reproduction of a painting inspired by the actual spot where the sign has been placed, or whatever remains of it. On leaving the station, you can go straight to the cemetery at the top of the hill, taking the Calpons footpath, to the right of the café opposite the station (to the left of the café is Daubigny's second house whose garden Vincent painted). It is precisely this road now named Rue Daubigny that you should take to pass directly in front of the church Notre-Dame d'Auvers, which is reached by a beautiful stone staircase. The road continues upward for three hundred meters, and the wheatfields are all around, just as Vincent painted them. The road divides in front of the cemetery, and a path crosses the field to the woods at the back of the village toward the studio of Daubigny. Take this path or go back the way you came

in order to reach the town hall and the Ravoux Inn. You will pass the park in which a statue of Van Gogh by Ossip Zadkine has been erected.

Every year in the spring, the Auvers-sur-Oise festival attracts famous musicians.

Things to see

Notre-Dame d'Auvers Church, 12th–13th century, is a modest example of classical Gothic architecture, with a beautiful portal and a remarkable tabernacle in gilded wood dating from the 17th century. The square-sided clock tower is typical of the French Vexin region. Van Gogh did a famous painting of this church (see page 23).

The cemetery

Not far from the entrance, a little to the left, at the foot of the wall, still nestled in ivy (see page 39), the twin graves of the Van Gogh brothers are of a moving simplicity. Other painters are also buried here: Norbert Goeneutte, Émile Boggio, Léonide Bourges, Charles Sprague Pierce, Eugène Murer, and Douglas Jones. There is a plaque paying respect to the painter Otto Freundlich, one of the great abstract masters, who died in a concentration camp.

Château Auvers

Rue de Léry, Tel. 33 (0)1 34 48 48 48. Open every day except Mondays from 10 am to 8 pm May to October, and from 10:00 am to 6:30 pm November to April.

Built in 1635 by Zénobi Léoni, financial adviser of Marie de Médicis, it was acquired in 1989 by the municipal council of Val-d'Oise. The gardens had become somewhat neglected when Van Gogh came to Auvers. It was from here that he painted the château in the distance. Finally, the beautiful original terraces have been restored and the whole effect is very elegant. A circuit-spectacle, *Journey to the Time of the Impressionists*, describes one of the most formidable adventures in the history of art. Information: Tel 33 (0)1 34 48 48 50.

La Maison de Van Gogh

8, Rue de la Sansonne (opposite the tourist information office) Tel. 33 (0)1 34 48 05 47, Fax 33 (0)1 42 27 33 40. Open every day from 10am to 6pm.

This is the former Ravoux Inn, classified as a historic

monument in 1985, which has been recently renovated and refurbished to accommodate the numerous tourists who come as if in pilgrimage to the place Vincent Van Gogh died. The bedroom where Vincent died in 1890 has been preserved intact. An informative audio-visual presentation is shown in an adjacent room, and a pleasant library holds the principal writings devoted to a painter about whom so much has been written. The inn itself is still open and the tavern can accommodate groups. For a substantial fee, it is also possible to join the Club of the Friends of Van Gogh's House.

Daubigny's Studio

61, Rue Daubigny, Tel. 33 (0)1 34 48 03 03, Fax 33 (0)1 30 36 79 42. Open in the afternoon from 2:00 pm to 6:30 pm from Easter to November 1st, closed on Mondays that are not public holidays.

This is the lovely house the painter Daubigny had built in 1861. He turned it into an artistic foyer, with visits from painters such as Corot and Daumier. With their help and that of his son Karl, himself a painter, he decorated his studio with elegant frescoes. His daughter Cécile's bedroom is also nicely decorated with scenes from fables and fairytales. This charming dwelling shows the sensitivity of an artist who was a forerunner of Impressionism and was greatly admired by Van Gogh.

Musée Daubigny

Rue de la Sansonne, Tel. 33 (0)1 30 36 80 20. Open every afternoon except Monday and Tuesday in winter from 2:00 pm to 5:30 pm, in summer from 2:30 pm to 6:30 pm.

This congenial little museum is on the first floor of the Manoir des Colombières, which it shares with the tourist information office. You can admire here the works of Daubigny and some others, including Guillaumin, Maufrat, and Schuffenecker. There is also an interesting collection of contemporary art.

Musée de l'Absinthe

44, Rue Callé (100 meters from the château), Tel. 33 (0)1 30 36 83 26. Open June to September, Wednesday to Sunday from 11:00 am to 6:00 pm, and all year on Saturdays and Sundays from 11:00 am to 6:00 pm. Symbols and myths of absinthe and its relationship with the artistic milieu of the 19th century.

Well, the day is probably not far off when they will paint olive trees in all kinds of ways, just as they paint the Dutch willow and pollard trees [...] The effect of daylight, of the sky, makes it possible to extract an infinity of subjects from the olive tree.
To Isaäcson, May 1890.

Dr. Gachet's House
78, Rue du Docteur Gachet.
This private dwelling is not open to the public.
Tourist information office
Manoir des Colombières, Rue de Sansonne,
Tel. 33 (0)1 30 36 10 06, Fax 33 (0)1 34 48 08 47.

RESTAURANTS
Maison de Van Gogh
Place de la Mairie, Tel. 33 (0)1 30 36 60 60, Fax 33 (0)1 30 36 60 61. Menus at 140 francs and 175 francs.
Les Canotiers
Rue de Léry, in the grounds of the château, Tel. 33 (0)1 34 48 05 05, Fax 33 (0)1 34 48 12 92. Menu at 125 francs.
Le Bistrot
In the grounds of the château. Buffet from 99 francs on Sundays and public holidays.
La Ferme de la Baratte
5, Rue Marceau, Tel. 33 (0)1 34 48 06 42.

HOTELS
There are no hotels in Auvers-sur-Oise itself, but many of the local residents offer bed and breakfast to visitors.
Novotel-Château de Maffliers***
Maffliers, Tel. 33 (0)1 34 43 93 05, Fax 33 (0)1 42 99 89 90. Set in beautiful grounds, a luxury establishment with swimming-pool, ten minutes from Auvers.
Hôtel d'Astrée**
3, Rue des Chênes-Émeraude, Cergy, Tel. 33 (0)1 34 24 94 94.

PROVENCE
Arles

Van Gogh, the painter from the north who embarked on his career as a painter with a somber palette and a love of Flemish chiaroscuro, discovered the bright colors the Impressionists were bringing into fashion in Paris. He then wanted to experience bright light for himself, and see the southern sunlight Toulouse-Lautrec had told him so much about. When he arrived in February, it was snowing! He took a room in Rue de la Cavalerie. Later, he moved into the Yellow House that he decorated with sunflowers to welcome Gauguin, and where he was living when he rather dramatically cut his ear. Both of these buildings were destroyed in the war, but on the site of the Yellow House, in Lamartine Square, the Hôtel Terminus-et-Van-Gogh reverently preserves Vincent's memory. The hôtel-Dieu, the Arles hospital where he was cared for by Dr. Rey, is still standing with its columned cloisters, central pond, and flower garden exactly as they were when the master painted them. Today this is known as the Espace Van Gogh.

It seems that Vincent knew the cafés better than any other part of the town. Most of them have disappeared, but on Place du Forum, the major meeting place for Arles socialites, there is a café that looks remarkably like the Café de Nuit. The brothels along the Rhône have also disappeared, with the departure of the Zouaves and the legislation prohibiting their existence. The Trinquetaille Bridge has been rebuilt, the traffic on the Rhône has dwindled, but the banks of the river are still wild enough to inspire you to take a walk along them and think about the walks Vincent took there in the company of pastor Salles. The town now has an international reputation for photography, and boasts an annual conference on the subject as well as a highly regarded school.

Things to see
The Arena
The Roman amphitheater is relatively well preserved and slightly larger than the one at Nîmes. It was cleared and restored during the 19th century. It seated more than 20,000 spectators around an arena dug out of rock.
Roman Theater
Less well preserved than the arena, but two very beautiful Corinthian columns still dominate the stage and the impressive marble tiles of the "orchestra pit."

Saint-Trophime

This ancient cathedral is a masterpiece of Provençal Romanesque art. It was an important stopping-place for pilgrims on the way to Saint-Jacques-de-Compostella. The portal, dating from the 12th century, is extremely beautiful, and the nave is generous in scope. Through the courtyard of the former archbishopric is a splendid cloister with a harmonious blend of the Romanesque and the Gothic. The capitals merit individual scrutiny.

The Réattu Museum

10, Rue du Grand-Prieuré, Tel. 33 (0)4 90 49 37 68. Open every day except public holidays April 1st to September 30th from 9:00 am to 12:00 noon, and from 2:00 pm to 6:00 pm, and October 1st to March 31st from 10:00 am to 12:00 noon, and from 2:00 pm to 4:30 pm.

The current Fine Arts Museum, the successor of the one Vincent found too academic, is still located in the handsome mansion house where the Arlesian painter Jacques Réattu (1760–1833) had his studio. You can admire his works, as well as those of other painters from the area, such as Antoine Raspal. But the highlight of the collection is a set of fifty-seven drawings presented by Picasso in 1971. The museum also holds a fine collection of photographs, which show the important place Arles has taken in contemporary photography.

Le Museon Arlaten

29, Rue de la République, Tel. 33 (0)4 90 93 58 11. Open every day from 9:00 am to 12:00 noon, and from 2:00 pm to 5:00 pm.

This regional ethnographic museum was founded by Frédéric Mistral in 1896.

L'Espace Van Gogh, place du Docteur Félix-Rey.

Tel. 33 (0)4 90 49 39 39, Fax 33 (0)4 90 49 99 21.

The former Arles hospital where Van Gogh was taken after he cut his ear, and where he painted the interior courtyard has been recently restored. It is now a municipal cultural complex.

Les Alyscamps

A vast necropolis situated on the former Via Aurelia, the Alyscamps are less frequented by the Arlesians of today than they were in the 19th century, but the place, which

Saint-Rémy, the hospital cloister.

I have a great wish to do the cypresses again and the Alpines (sic), and when making long trips in all directions, I have often carefully noted some subjects, and I know good places for when the fine weather comes.
To Theo, December 1889.

is an important archeological site, has retained all its former charm. The first bishops of Arles were buried here.

Saint-Honorat Church, 12th century, a veritable pearl of Romanesque architecture.

The Langlois Bridge, which Vincent found had Japanese charm, today has a twin in the south of Arles. This drawbridge is set in the raised position because it would be impossible to lower it, given that the canal on which it was built is too narrow for it!

Montmajour Abbey

Route de Fontvieille, Tel. 33 (0) 4 90 54 64 17. Open every day in winter from 9:00 am to 12:00 noon, and from 2:00 pm to 7:00 pm, in summer from 9:00 am to 7:00 pm. Montmajour Abbey, as the name suggests, stands on the highest point of the Arles plain. A hermitage was built in the rock as early as the 10th century, then later a necropolis and a chapel were built. The crypt of the chapel served as the foundation for the magnificent abbey itself, which is of imposing dimensions. There is a panoramic view from the Pons-de-l'Orme tower, built in the 15th century. The exquisite architecture is completed by the cloister and the convent buildings, both of which have been remarkably restored.

Vincent Van Gogh Foundation

26, rond-point des Arènes-d'Arles, Tel. 33 (0)4 90 49 94 04. Open every day except public holidays, opening hours vary. Contemporary artists (Bacon, Hockney, Botero, etc.) pay homage to Van Gogh.

La Rose des Vents

18, Rue Diderot, Tel. 33 (0)4 90 96 15 85. Open everyday except in winter with varying times.

Maïté Dubocquet, a passionate Arlésienne, was an antiques dealer for many years. Her beautiful house is now entirely devoted to Vincent Van Gogh. An unusual exhibition shows (with reproductions, of course) all the paintings Vincent painted on local subjects. Off-season, the hostess travels the globe as a lecturer with the Alliance Française. She reserves a warm Provençale welcome to visitors who share her passion for Van Gogh. You can even see the shawl Mme Ginoux was wearing when Vincent painted her portrait.

Tourist information office

Esplanade Charles-de-Gaulle, Tel. 33 (0)4 90 18 41 20, Fax 33 (0)4 90 18 41 29.

HOTELS

Grand Hôtel Nord-Pinus**

Place du Forum, Tel. 33 (0)4 90 93 44 44, Fax 33 (0)4 90 93 34 00.

Hôtel Jules-César**

9 Boulevard des Lices, Tel. 33 (0)4 90 93 43 20, Fax 33 (0)4 90 93 33 47. Luxury Relais and Châteaux around an old Carmelite cloister.

Hôtel d'Arlatan*

26, Rue Sauvage, Tel. 33 (0)4 90 93 56 66, Fax 33 (0)4 90 49 68 45.

Mas de la Chapelle*

Petite route de Tarascon, Tel. 33 (0)4 90 93 23 15, Fax 33 (0)4 90 96 53 74. Old manor house set in charming grounds, with an excellent restaurant in the magnificent chapel.

Hôtel Terminus et Van Gogh*

5, Place Lamartine, Tel. 33 (0)4 90 96 12 32.
This pleasant little hotel is proud to have been built on the site of the Yellow House.

RESTAURANTS

Lou Marques

Boulevard des Lices, Tel. 33 (0)4 90 93 43 20, Fax 33 (0)4 90 93 33 47. The best restaurant in Arles, offering distinctive, refined cuisine.

L'Olivier

1bis, Rue Réattu, Tel. 33 (0)4 90 49 64 88. A more modest restaurant, cosier than the previous one, but almost as remarkable.

Saint-Rémy-de-Provence

When Vincent was a resident at Saint-Paul-de-Mausole in Saint-Rémy, he created about a hundred and fifty paintings. While he was staying in this hospital, which is situated outside the town, not far from the ruins of Glanum, he experienced both madness and the accomplishment of his genius. He often went out to paint the Alpilles hills, or closer to hand, the amazing quarries that can still be seen in the neighboring woods. Saint-Rémy is also the town where the prophet Nostradamus was born.

It seems to me that it is not much warmer here in summer than at home, as far as being oppressed by it is concerned, as the air is much clearer, more transparent here. In addition, we very often have a strong wind, the mistral.
To his mother, June 1889.

What is beautiful in the south are the vineyards, but they are in the plain or on the hillsides.
To his mother, June 1889.

Things to see

Glanum and the Roman Ruins
Open every day except public holidays from April 1st to September 30th from 9:00 am to 6:00 pm, and from October 1st to March 31st from 8:30 am to 12:30 pm and from 2:00 pm to 5:00 pm.

L'Arc de Triomphe and the Mausoleum of the Julii
are among the most remarkable monuments the Romans left on French soil. They bear witness to the importance of a Gallo-Roman town destroyed by the Barbarians, the vestiges of which were covered with earth. Archeological digs began in 1921 and uncovered the remains.

Monastère Saint-Paul-de-Mausole
Open every day from 9:00 am to 12:00 noon and from 2:00 pm to 6:00 pm in summer, 9:00 am to 12:00 noon and 1:00 pm 5:00 pm in winter. The hospital Van Gogh stayed in, which is still a hospital today, is housed in this masterpiece of Provençal Romanesque art, with an admirable cloister and chapel.

Hôtel de Sade, Archeological Center
Place Favier, Tel. 33 (0)4 90 92 64 04, Fax 33 (0)4 90 92 64 02. Open every day from March 26th to December 31st .

Musée des Alpilles
Place Favier, Tel. 33 (0)4 90 92 68 24, fax 33 (0)4 90 92 28 63. Open every day from 10:00 am to 12:00 noon and from 2:00 pm to 6:00 pm; in summer from 10:00 am to 12:00 noon and from 3:00 pm to 8:00 pm. This is a museum containing regional treasures, housed in the handsome Mistral de Montdragon mansion.

La Collégiale Saint-Martin
Only the Gothic belltower remains of the old collegiate church. Inside, there are some interesting paintings and statues, and the organ with sixty-two stops is a master-piece of modern craftsmanship.

Donation Mario Prassinos, Chapelle Notre-Dame-de-Pitié
Avenue Durand-Maillane, Tel. 33 (0)4 90 92 35 13. Open every day April 1st to June 30th from 2:00 pm to 6:00 pm; July 1st to August 31st from 3:00 pm to 7:00 pm; September 1st to 30th from 2:00 pm to 6:00 pm; October 1st to March 31st Monday, Tuesday, Thursday, Friday, Sunday from 1:30 pm to 5:30 pm.

The painter Mario Prassinos lived in Eygalières, not far from Saint-Rémy. He donated around a hundred paintings to the State.

There are many promenades and guided tours of the places Van Gogh painted, available all year round. Information from the tourist information office.

Tourist information office
Place Jean-Jaurès, Tel. 33 (0)4 90 92 05 22, Fax 33 (0)4 90 92 38 52.

HOTELS

Le Mas de la Brune****
Eygalières (12 kilometers from Saint-Rémy), Tel. 33 (0)4 90 95 90 77. A delightful hotel-restaurant in the countryside.

Vallon de Valrugues
Chemin Canto-Cigalo, Tel. 33 (0)4 90 92 04 40, Fax 33 (0)4 90 92 44 01.

Château des Alpilles****
Route départementale 31, BP 2, Tel. 33 (0)4 90 92 03 33, Fax 33 (0)4 90 92 45 17.

Domaine de Valmouriane****
Petite route des Baux (5 kilometers from Saint-Rémy), Tel. 33 (0)4 90 92 44 62, Fax 33 (0)4 90 92 37 32.

Le Castelet des Alpilles***
6, Place Mireille, Tel. 33 (0)4 90 92 07 21, Fax 33 (0)4 90 92 52 03.

Château de Roussan***
Route de Tarascon (2 kilometers from Saint-Rémy) Tel. 33 (0)4 90 92 11 63, Fax 33 (0)4 90 92 37 32.

Hôtel des Antiques***
15, Avenue Pasteur, Tel. 33 (0)4 90 92 03 02, Fax 33 (0)4 90 92 50 40.

Le Mas des Carassins***
1, chemin Gaulois, Tel. 33 (0)4 90 92 15 48.

RESTAURANTS

Vallon de Valrugues
Chemin Canto-Cigalo.
Tel. 33 (0)4 90 92 04 40, Fax 33 (0)4 90 92 44 01.

Le Marceau
13, Boulevard Marceau, Tel. 33 (0)4 90 92 37 11.

Domaine de Valmouriane
Petite route des Baux. Tel. 33 (0)4 90 92 44 62, Fax 33 (0)4 90 92 44 32.

Le Bistrot des Alpilles
15, Boulevard Mirabeau.
Tel. 33 (0)4 90 92 09 17, Fax 33 (0)4 90 92 38 73.

Tarascon

It was from Tarascon that Vincent took the train to return to Paris, when he left Saint-Rémy. A keen reader of Alphonse Daudet, he liked the ridiculous character called Tartarin de Tarascon, the unheroic hunter who continues to amuse the young and not so young.

Things to see
Le Château. Boulevard du Roi-René, Tel. 33 (0)4 90 91 01 93. Open every day, October 1st to March 31st from 9:00 am to 12:00 noon and 2:00 pm to 5:00 pm; April 1st to September 30th from 9:00 am to 7:00 pm.
This impressive fortress stands on the banks of the Rhône. King René supervised its completion in the 15th century. The interior holds some good examples of the flamboyant Gothic style.
La Collégiale Sainte-Marthe.
A beautiful Gothic nave and many works of art.
Maison de Tartarin. 55 bis, Boulevard Itam, Tel. 33 (0)4 90 91 05 08. Open every day except Sunday from 10:00 am to 12:00 noon and from 2:30 pm to 7:00 pm. Closed between December 15th and March 15th. The character is fictional, but the house is real, thanks to an amusing initiative on the part of the local council.
Tourist Office
59, Rue des Halles, Tel. 33 (0)4 90 91 03 52, Fax 33 (0)4 90 91 22 96.

HOTELS
Le Mazet des Roches***
Route de Fontvieille, Tel. 33 (0)4 90 91 34 89, Fax 33 (0)4 90 43 53 29.
Hôtel de Provence***
7, Boulevard Victor-Hugo, Tel. 33 (0)4 90 91 06 43, Fax 33 (0)4 90 43 58 13.

Fontvieille

Van Gogh was fond of walking, and often covered the 12 kilo-meters separating Fontvieille from Arles to visit his artist friends in a village Alphonse Daudet lived in.

Things to see
Chapelle Saint-Gabriel. A good example of Provençal Romanesque (12th century) architecture.
Notre-Dame-du-Château. A pretty chapel on a slope of the Alpilles hills.

Saintes-Maries-de-la-Mer

Van Gogh loved this little village, with its fishermen and gypsies. He spent a week here and painted some admirable works, including the only seascapes he painted as a mature artist. The village has lost much of its charm since Vincent's time.

Things to see
The church. This is a little fortress with an elegant interior. In the crypt are the venerable relics of Saint Sarah, patron saint of gypsies. A magnificent panoramic view of the whole Camargue region can be seen from the open roof.
Baroncelli Museum. Rue Victor-Hugo. Open every

And then this blessed Fontvieille would be a gold mine for them, but the natives are like Zola's poor peasants, innocent and gentle beings, as we know.
To Theo, July 29, 1888.

I will be at the Louvre, ready to leave at noon if you wish. Please let me know when you wish to come to the Salle Carrée.
Note to Theo, announcing his impromptu arrival in Paris on February 28, 1886.

day except Tuesday from 10:00 am to 12:00 noon and from 2:00 pm to 6:00 pm. Closed in winter. Ethnographic museum of life in Provence.

Tourist information office
5, Avenue Van Gogh, Tel. 33 (0)4 90 97 82 55, Fax 33 (0)4 90 97 71 15.

HOTEL-RESTAURANT
Mas de la Fouque*.** Route d'Aigues-Mortes, Tel. 33 (0)4 90 97 81 02, Fax 33 (0)4 90 97 96 84.

PARIS

Van Gogh first came to Paris as an art dealer at a time when he had already lost faith in the profession in which he had previously shown himself to be both competent and conscientious. He came back when he had decided to become a painter after his failed attempt to become a pastor or lay preacher. Paris, for Vincent, meant Theo, his younger brother who had been helping him financially for some time. Theo, the art dealer, was supportive of Vincent. Paris also meant Impressionism, an avant-garde movement in painting that he knew little about, but that he wanted to witness while he was attempting to free himself from the chiaroscuro so dear to the painters from Flanders.

Paris, for Van Gogh, was essentially Montmartre and the northern suburbs, toward Clichy, Asnières, Aubervilliers, and the banks of the Seine. Montmartre was edging toward the center of the town, under the influence of Haussmann's urban-development scheme, but its windmills still gave the hill of the Paris commune a country air. Bohemians and bourgeois mingled in the numerous cabarets and open-air cafés, giving the quarter an atmosphere of perpetual celebration. Vincent naturally painted some scenes here. Paris also meant the Louvre, the Luxembourg museum, places where one could admire historical or contemporary painting. This was also the quarter with the "grand boulevards," where the major art dealers had their premises.

Things to see
Montmartre
Vincent and Theo lived at 54, Rue Lepic. Toulouse-Lautrec had a studio on the corner of Rue Caulaincourt and Rue Tourlaque. His friends dropped in to see him there, and Vincent visited him more than once, taking with him his paintings that he would place on the floor for people to see, but the atmosphere was festive, and none of the other visitors were really interested in his artistic concerns.

Le Moulin de la Galette
It still has its sails, at the top of Rue Lepic, not far from the Allée des Brouillards where Renoir had a pretty house (he also had a studio at 73, Rue Caulaincourt, at the same address as Steinlen, and another at 12, Rue Cortot, in the beautiful mansion that today houses the Musée de Montmartre).

The old quarter of Nouvelle-Athènes
The Clichy district (Place, Boulevard, and Avenue Clichy) is somewhat discouraging to the visitor today, but the Nouvelle-Athènes quarter, below Place Pigalle, has retained much of its former charm. Impressionism took over the torch from the Romantic movement in these streets lined with elegant buildings, where, in the attics, there are many artists' studios. Theo Van Gogh first lived in Rue Victor-Masé, which was then called Rue Laval. Degas had a house (which has been demolished) at no. 37. Père Tanguy's artists' shop was in Rue Clauzel, but there is no plaque to inform the visitor that for several years this was the only place in Paris where it was possible to see the paintings of Van Gogh or Cézanne.

The Louvre
1, Place du Carrousel, 75001, Tel. 33 (0)1 40 20 97 55. Open every day from 9:00 am to 6:00 pm, except Tuesday, and till 9:45 pm on Wednesday night.

The museum has changed a lot since the day Vincent arranged to meet his brother there when he arrived from Antwerp. Vincent spent hours in the Louvre contemplating the mysterious beauty of so many masterpieces, and the visitor can't fail to think of him when looking at the paintings he observed at such length.

Le Musée d'Orsay
1, Rue de Bellechasse, 75007, Tel. 33 (0)1 45 49 11 11. Open every day except Monday from 10:00 am to 6:00 pm.

The paintings by Van Gogh that belonged to Doctor Gachet were donated to the State by the doctor's heirs, and you can now see them here, along with a few others: *The Restaurant de la Sirène, Italian Woman, L'Arlésienne, The Church at Auvers-sur-Oise, Vincent's Room in Arles, The Siesta,* the portrait of Dr. Gachet,

and two self-portraits by Vincent.

Le Musée du Vieux-Montmartre

12, Rue Cortot, 75018, Tel. 33 (0)1 46 06 61 11. Open every day except Monday from 11:00 am to 6:00 pm.

This handsome mansion, frequented by Pierre-Auguste Renoir, Émile Bernard, Raoul Dufy, Maurice Utrillo, and Suzanne Valadon, once overlooked the vineyards of Montmartre. A congenial museum with souvenirs of Montmartre as it was at the end of the 19th century.

Le Musée de la Vie Romantique

16, Rue Chaptal, 75009, Tel. 33 (0)1 48 74 95 38. Open every day from 10:00 am to 5:40 pm, except Monday.

The house and studio of Dutch painter Ary Scheffer have been converted into a charming museum, partly devoted to this artist from Dordrecht whom Vincent admired. The museum also houses a significant collection of works and various objects related to the life and work of Chopin's mistress, the writer George Sand.

Tourist information office

127, Avenue des Champs-Élysées, 75008, Tel. 33 (0)1 49 52 53 54.

HOTELS

Only hotels and restaurants in the area of Paris where Vincent Van Gogh lived are given here.

Terrass Hotel**

12 and 14, Rue Joseph-de-Maistre, 75018, Tel. 33 (0)1 46 06 72 85, Fax 33 (0)1 42 52 29 11.

Moulin*

39, Rue Fontaine, 75009, Tel. 33 (0)1 42 81 93 25, Fax 33 (0)1 40 70 23 81.

La Tour d'Auvergne*

10, Rue de la Tour d'Auvergne, 75009, Tel. 33 (0)1 48 78 61 60, Fax 33 (0)1 49 95 99 00.

Amiral Duperré**

32, Rue Duperré, 75009, Tel. 33 (0)1 42 81 55 33, Fax 33 (0)1 44 63 04 73.

Regyn's Montmartre**

18, Place des Abbesses, 75018, Tel. 33 (0)1 42 54 45 21, Fax 33 (0)1 42 23 76 69.

Tim Hôtel Montmartre**

11, Rue Ravignan, 75018, Tel. 33 (0)1 42 55 74 79, Fax 33 (0)1 42 55 71 01.

Near the station I turned to the left, where all the windmills are, along a canal with elms; everything there reminds one of Rembrandt's etchings.
To Theo, May 19, 1877.

RESTAURANTS

À Beauvilliers
52, Rue Lamarck, 75018, Tel. 33 (0)1 42 54 54 42. The best table in the quarter, on the north of the hill of Montmartre. Creative traditional cuisine, but high quality has its price.

Le Bistrot Blanc
52, Rue Blanche, 75009, Tel. 33 (0)1 42 85 05 30. Parisian elegance and refinement. Reasonably priced.

Charlot Roi des Coquillages
81, Boulevard de Clichy, 75009, Tel. 33 (0)1 48 74 49 64. A large brasserie for lovers of seafood and night owls on Place Clichy.

Charlot Ier les Merveilles de la Mer
128 bis, Boulevard de Clichy, 75009, Tel. 33 (0)1 45 22 47 08. Another large brasserie, not far from the former, and also specializing in seafood.

Le Restaurant
32, Rue Véron, 75018, Tel. 42 23 06 22. Distinctive, high-quality cuisine in a relaxed atmosphere. Moderately priced.

Le Table d'Anvers
2, Place d'Anvers 75009, Tel. 33 (0)1 48 78 35 21. The restaurant with the highest reputation in the quarter, for lovers of creative cuisine who are not on a struggling-artist's budget.

Taka
1, Rue Véron, 75018, Tel. 33 (0)1 42 23 74 16. An excellent Japanese restaurant, open only in the evening.

TEA ROOM

Tea Follies
6, Place Gustave-Toudouze, 75009, Tel. 33 (0)1 42 80 08 44. Very refined light cuisine on a pretty square where the tables are laid outdoors in the summer season.

THE NORTH
Amsterdam

Vincent Van Gogh stayed in Amsterdam while he was studying to become a pastor. He had already come to the town often to see his uncles and visit the museums when, as an employee of Goupile&Cie at The Hague, he became passionately interested in art. He lived at the harbor with his Uncle Jan, who was head of the municipal dockyards. He went for long walks, both by night and by day, through the streets along the canals in the town center. He frequented the Jewish quarter where his Latin and Greek teacher lived. He often went to the flower market on the Singel. And he would walk along the dunes, among the windmills, toward the sea.

Things to see

The center of the town, with its concentric canals, the Singel, the Herengracht, the Kaisergracht, the Prinsengracht. The absence of dense traffic makes it pleasant to walk along the edge of the water between the rows of beautiful old houses. Here and there, friendly cafés offer a warm atmosphere when the weather is too cold and damp.

Rijksmuseum
Stadhouderskade 42, Tel. (31 20) 673 2121. Open every day from 10:00 am to 5:00 pm.

This museum was built in 1885 to replace the one where Vincent admired the masterpieces of Dutch art. *The Kitchen Maid* by Vermeer and Rembrandt's *The Night Watch* are the two most famous paintings in the museum.

Stedelijk Museum
Paulus Potterstraat 13, Tel. (31 20) 573 2737. Open every day from 11:00 am to 5:00 pm.

This is Amsterdam's modern art museum, which has a wealth of 19th- and 20th-century paintings, including works by Mondrian and Malevitch. The museum has a very dynamic policy with regard to contemporary art.

The Van Gogh Museum
Paulus Potterstraat 7, Tel. (31 20) 570 5200. Open every day from 10:00 am to 5:00 pm.

A shrine to the memory of Van Gogh, this museum opened in 1973 to house the collection donated by the painter's nephew and heir. It holds over two hundred

Quite near our house there is a spot from which one can see, far below, a large part of the Borinage, with the chimneys, the mounds of coal, the little miners' cottages, the little black figures scurrying by day, like ants in a nest.
To Theo, June 1879.

paintings and approximately five hundred drawings, including *The Potato Eaters*, *The Artist's Bedroom at Arles*, *Wheatfield with Crows*.

Museum Het Rembrandthuis. Jodenbreestraat 4-6, Tel. (31 20) 624 9486. Open from 10:00 am to 5:00 pm Monday to Saturday, and from 1:00 pm to 5:00 pm on Sundays and public holidays.

This pretty mansion house in the former Jewish quarter has been well restored, and presents almost the entire collection of Rembrandt's etchings.

Tourist information office
Stationplein 10, 1012 AB, Tel. (31 20) 551 25 12.

HOTELS

There are a great many hotels in Amsterdam. From grand palaces to charming little hotels, a warm welcome is available in all. Here you will find some high-class establishments. It is often necessary to make reservations well in advance.

Ambassade
Herengracht 335-353, 1016 AZ, Tel. (31 20) 626 33 33, Fax (31 20) 624 5321. Charming and elegant with a refined decor at a reasonable price.

Amstel Intercontinental, Prof. Tulpplein, 1018 GX, Tel. (31 20) 622 60 60, Fax (31 20) 622 5808. Luxurious surroundings at a luxurious price.

Canal House
Keizersgracht 148, 1015 CX, Tel. (31 20) 622 5182, Fax (31 20) 624 1317. Charming, and the least expensive on our list.

Grand Amsterdam, Oudezijds Voorburgvaal 197, 1012 EX, Tel. (31 20) 555 3111, fax (31 20) 555 32 22. The former town hall, very refined.

Grand Hotel Krasnapolsky
Dam 9, 1012 JS, Tel. (31 20) 554 9111, Fax (31 20) 622 8607. Enormous and centrally situated, with a long history of famous visitors.

Pulitzer
Prinsengracht 315-331, 1016 GZ, Tel. (31 20) 523 5235, Fax (31 20) 627 67 53. A luxury and highly modern establishment, well-situated between two canals.

RESTAURANTS

Amsterdam has many very good restaurants with tradi-

tional fare, French cuisine, and various exotic cuisines.

Café Roux-Grand Amsterdam
Oudezijds Voorburgvaal 197, Tel. (31 20) 555 3560. An excellent restaurant run by Albert Roux as part of the Hotel Grand Amsterdam.

Tom Yam
Staalstraat 22, Tel. (31 20) 622 9533. Excellent cuisine of Thai inspiration by a Dutch chef.

The Borinage

It was in the Belgian mining area of the Borinage, where the workers lived in abject poverty, that Van Gogh put his religious vocation to the test, first as an apprentice pastor, then as a lay preacher. This was also where he began the metamorphosis that was to make him an artist. In Wasmes, Pâturages, and Cuesmes, he lived among the poor and tried to follow the teachings of the Gospel as closely as possible.

Things to see

Vincent Van Gogh's House
3, Rue du Pavillon, 7033 Cuesmes (Mons), Tel. (32) 35 56 11. Open every day except Monday from 10:00 am to 6:00 pm.

Vincent spent six months here with the Decrucq family during his last stay in the Borinage. This house was in ruins, and a considerable effort was made to save it from sinking into the marsh. Surrounded by trees, it is now one of the most moving stages along the path Vincent followed. A series of reproductions are on exhibition to refresh the memory of this episode in the painter's life.

Le Grand Hornu
Industrial development dating from the beginning of the 19th century in the village of Hornu, 10 kilometers from Mons, stands as an example of social architecture that was astonishingly modern for its time. It narrowly escaped demolition by being turned into a museum and cultural center.

La Collégiale Sainte-Waudru in Mons is a masterpiece of 15th-century Gothic art in the Brabant.

Mons Tourist Office
20, Grand-Place, Tel. (32) 33 55 80.

HOTEL
Métropole
20, Rue Léopold II, Tel. (32) 31 46 64.
RESTAURANTS
Devos, 7, Rue de la Coupe, Tel. (32) 35 13 35.
Mairesse, 77, Chaussée de Mariemont, Tel. (32) 44 21 96.

The Hague

Van Gogh came to The Hague at the age of sixteen to begin his apprenticeship as a print dealer at the Goupil Art Gallery. He was a frequent visitor to the museum, which he later returned to when he had started to paint and once again settled in the capital of The Netherlands. It was here that he lived in a household for the first and last time. However, it was first and foremost at The Hague that he became the great master we know, investing his exorbitant energy in the conquest of the art of drawing.

Things to see
The Mauritshuis. Open Tuesday and Saturday from 10:00 am to 5:00 pm, and public holidays from 11:00 am to 5:00 pm.

This museum is mainly devoted to the Golden Age of Dutch painting (17th century), including Vermeer's superb *Girl with a Pearl Earring* and *View of Delft,* but it also houses masterpieces of the Flemish school of the 15th and 16th centuries, and some German masters.
Tourist Office
Koningin Julianaplein 30, 2595 AA, Tel. (31 70) 54 62 00.

HOTELS
Hôtel des Indes
Langevoorhout 54, 2514 EG, Tel. (31 70) 363 29 32, Fax (31 70) 345 17 21.
Pullman Central
Spui 180, 2511 BW, Tel. (31 70) 363 67 00, Fax (31 70) 363 93 98.

RESTAURANTS
La Cigogne
Van Stolkweg 1, Tel. (31 70) 5251 61.
Corona

Buitenhof 42, 2513 AH, Tel. (31 70) 363 79 30.

Nuenen

This village, where his father was pastor, was the last place Van Gogh stayed in Holland after his escapade in the Borinage. He had by then really taken the decision to be a full-time painter, to his parents' sorrow. Today it is a delightful little town with elegant houses under the shade of the trees.

Things to see
The small church where Theodorus Van Gogh was pastor, and which his son depicted more than once in his paintings.
The house where Van Gogh's family lived is not open to the public.
A windmill drawn by Vincent.
The two watermills he painted.
The Stedelijk Van Abbe Museum
Bilderdijklaan 10, Eindhoven. Open Tuesday to Sunday from 11:00 am to 5:00 pm.

Nuenen is only seven kilometers from Eindhoven, where there is a remarkable museum of modern art that has a collection of works by Chagall, as well as a good selection of paintings from the main artistic movements of the century, from Cubism onwards.
Information Center on Vincent Van Gogh (next to the church). Open weekdays except Saturday from 9:00 am to 12:00 noon and from 2:00 pm to 5:00 pm.

HOTELS
Cocagne
Vestdijk 47, 5611 CA, Tel. (31 40) 44 47 55, Fax 44 01 48.
Holiday Inn
Veldm. Montgomerylaan 1, 5612 BA, Tel. (31 40) 43 32 22, Fax 44 92 35.
Altea
Markt 35, 5690 HE, Tel. (31 40) 45 45 45, Fax 45 36 45.

RESTAURANTS
L'Etoile, restaurant of the Hotel Cocagne.
Vestdijk 47, Tel. (31 40) 44 47 55, fax 44 01 48.
Der Karpeendonske Hoeve
Sumatralaan, 5631 AA, Tel. (31 40) 81 36 63.

But in case you do not know the Geest and the Mud's End, etc. that is to say the Whitechapel of The Hague with all its alleys and courts, I offer to accompany you there, whenever you come to The Hague again.
To Van Rappard, May 1882.

Right now, I have a magnificent view from the window of my studio. The city with its towers and roofs and smoking chimneys stands out as a dark, somber silhouette against the luminous horizon.
To Theo, October 1882.

Ravensdonck
Ten Hagestraat 2, Tel.(31 40) 44 31 42.

Zundert

Vincent Van Gogh's native village holds few memories of the painter and few reminders of the period. On the other hand, the neighboring town of Breda (17 kilometers away, on the road to Antwerp), is not lacking in charm, with its large square and pedestrian precincts.

Things to see
The house Van Gogh was born in, opposite the town hall, is now a real-estate agent. There is a commemorative plaque on the wall.
The church in which he was christened, and in which his father was pastor, is charming, surrounded by chestnut trees and a small cemetery in which you can see the grave of the elder brother, also called Vincent (to visit the church, ask at the small house in the courtyard).
Tourist Office
Cultureel Centrum Van Gogh, Molenstraat 5, 4881 CP, Tel. (31 76) 5971999, Fax 5976192.

HOTELS
De Roskam, Molenstraat 1, 4881 CP Zundert, Tel. (31 76) 5972357, Fax 5975215.
Mastbosch
Burgmeister Kerstenlaan 20, 4837 BM Breda, Tel. (31 76) 65 00 50, Fax 10 00 40.
Huis Den Deyl, Mareellenweg 8, 48 36 BH Breda, Tel. (31 76) 65 36 16.

RESTAURANTS
Auberge de Arent, Schoolstraat 2, Breda. Tel. (31 76) 14 46 01.
Mirabelle, Doktor Batenburglaan 76, Tel. (31 76) 65 66 50.

Index

TABLE OF VAN GOGH'S WORKS

Bibliography

Antonin Artaud, *Van Gogh, le suicidé de la société*, Gallimard, Paris, 1974.

Pascal Bonafoux, *Van Gogh*, Editions du Chêne, Paris, 1989.

Pascal Bonafoux, *Van Gogh, le soleil en face*, Découvertes Gallimard, Paris, 1988.

Jean-Paul Clébert and Pierre Richard, *La Provence de Van Gogh*, Edisud, 1989.

Jean-Paul Crespelle, *Guide de la France impressionniste*, Hazan, Paris, 1990.

Vivianne Forrester, *Van Gogh*, Le Seuil, Paris, 1983.

Pierre Leprohon, *Vincent Van Gogh*, Editions Corymbe, Le Cannet de Cannes, 1972.

Roland Pécout, *Itinéraires de Van Gogh en Provence*, Les Editions de Paris, Paris, 1994.

Vincent Van Gogh, *Correspondance générale*, (3 vol.), Biblos/Gallimard, Paris, 1990.

Vincent Van Gogh, *Lettres à son frère Théo*, L'Imaginaire/Gallimard, Paris, 1988.

Kenneth White, *Van Gogh*, Flohic, 1994.

Ronald Pickvance, *Vincent Van Gogh en Arles*, Skira, Geneva, 1985.

David Sweetman, *Une vie de Vincent Van Gogh*, Presses de la Renaissance, Paris, 1990.

CATALOGUES

Vincent Van Gogh, peintures, Rijksmuseum Vincent Van Gogh, Amsterdam, 1990.

Vincent Van Gogh, dessins, Rijksmuseum Kröller-Müller, Otterlo 1990.

TOURIST GUIDES

Amsterdam, Guides Voir, Hachette, Paris, 1989.

Arles et la Camargue, Guides Bleus, Hachette, Paris, 1987.

Belgique Luxembourg, Guides Bleus, Hachette, Paris, 1987.

Hollande, Guides Bleus, Hachette, Paris, 1991.

Provence Alpes Côte d'Azur, Guides Bleus, Hachette, Paris, 1991.

PENGUIN STUDIO
Published by the Penguin Group
Penguin Putnam Inc., 375 Hudson Street,
New York, New York, 10014, U.S.A.

Penguin Books, Ltd, 27 Wrights Lane,
London W8 5TZ, England

Penguin Books Australia Ltd, Ringwood,
Victoria, Australia

Penguin Books Canada Ltd, 10 Alcorn Avenue, Suite 300,
Toronto, Ontario, Canada M4 V3 B2

Penguin Books (N.Z.) Ltd, 182-90 Wairau Road,
Auckland 10, New Zealand

Penguin Books Ltd, Registered Offices:
Harmondsworth, Middlesex, England

First published by Penguin Studio, a member of Penguin Putnam Inc.

First Printing, October 1998
10 9 8 7 6 5 4 3 2 1

PHOTOGRAPH CREDITS

All the photographs in this book were taken by Jean-Marie del Moral, with the exception of reproductions of paintings.

© AKG: pages 72, 80, 93, 115
© Artephot/A. Held: pages 25, 26, 32, 43, 50, 55, 64, 68, 75, 76, 83, 94, 97, 100, 105, 118, 131, 137
© Artephot/Bridgeman Art Library: pages 129, 134
© Artephot/Faillet: page 11
© Artephot/Nimatallah: pages 20, 36
© Artephot/Takase: pages 15, 23
© Artephot/Varga: page 61
© Illustria: pages 87, 99, 138, 141
© Rijksmusem Vincent Van Gogh/B. V't Lanthuys: page 106
© RMN/G. Blot: page 91
© RMN/H. Lewandowski: page 110
© Roger Viollet: page 52
D. R.: Pages 54, 79, 108

ACKNOWLEDGMENTS

Gilles Plazy and Jean-Marie del Moral would like to thank all those who helped them to tread this sacred ground, especially Mr. and Mrs. Remillieux, Charles Dominique Janssens, Roger Mourot, Yves Schwarzbach, and Pascal Bazilé.

Editorial Manager: Laurence Basset; *Assisted by:* Cécile Degorce;
Layout: Christopher Evans; *Photo Engraving:* Offset Publicité, Maison-Alfort.

Printed in Spain by Cayfosa, Barcelona.

ISBN: 0-670-88250-X

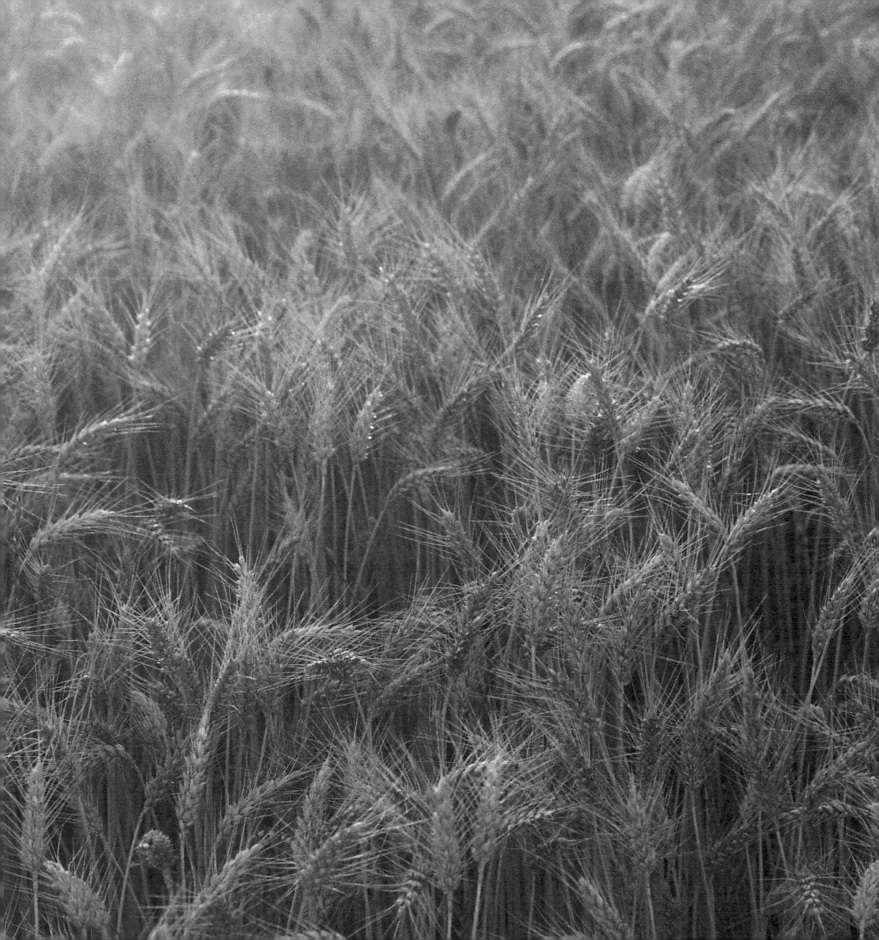